WOMEN'S FASHION AND LIFESTYLE IN JAPANESE ART

Beautiful Women
Japanese Prints Coloring Book

Noor Azlina Yun

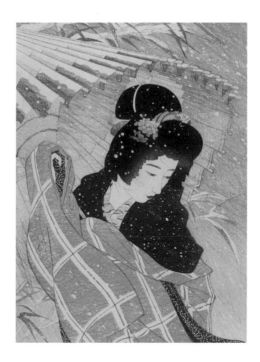

TUTTLE Publishing

Tokyo | Rutland, Vermont | Singapore

Published by Tuttle Publishing,
an imprint of Periplus Editions (HK) Ltd

www.tuttlepublishing.com

Copyright © 2017 by Periplus Editions (HK) Ltd.

ISBN 978-4-8053-1469-2

Distributed by

North America, Latin America & Europe
Tuttle Publishing
364 Innovation Drive
North Clarendon
VT 05759-9436 U.S.A.
Tel: 1 (802) 773-8930
Fax: 1 (802) 773-6993
info@tuttlepublishing.com
www.tuttlepublishing.com

Japan
Tuttle Publishing
Yaekari Building, 3rd Floor
5-4-12 Osaki Shinagawa-ku
Tokyo 141-0032
Tel: (81) 3 5437-0171
Fax: (81) 3 5437-0755
sales@tuttle.co.jp
www.tuttle.co.jp

Asia Pacific
Berkeley Books Pte. Ltd.
61 Tai Seng Avenue, #02-12
Singapore 534167
Tel: (65) 6280-1330
Fax: (65) 6280-6290
inquiries@periplus.com.sg
www.periplus.com

19 18 17
10 9 8 7 6 5 4 3 2 1

Printed in China 1708RR

TUTTLE PUBLISHING® is a registered trademark of Tuttle Publishing, a division of Periplus Editions (HK) Ltd.

About Tuttle: "Books to Span the East and West"

Our core mission at Tuttle Publishing is to create books which bring people together one page at a time. Tuttle was founded in 1832 in the small New England town of Rutland, Vermont (USA). Our fundamental values remain as strong today as they were then—to publish best-in-class books informing the English-speaking world about the countries and peoples of Asia. The world has become a smaller place today and Asia's economic, cultural and political influence has expanded, yet the need for meaningful dialogue and information about this diverse region has never been greater. Since 1948, Tuttle has been a leader in publishing books on the cultures, arts, cuisines, languages and literatures of Asia. Our authors and photographers have won numerous awards and Tuttle has published thousands of books on subjects ranging from martial arts to paper crafts. We welcome you to explore the wealth of information available on Asia at **www.tuttlepublishing.com**.

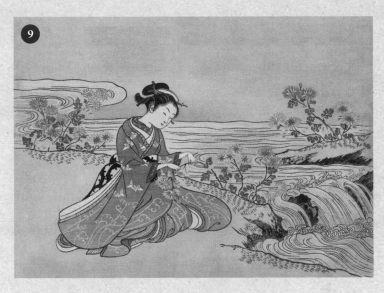
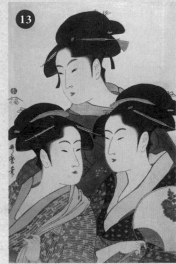
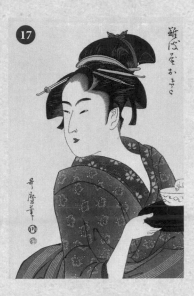

CONTENTS

6 **Introduction**

9 Suzuki Harunobu (1725–1770), "Transformation of Kikujiro" (*Yatsushi Kikujiro*), a.k.a. "Collecting Chrysanthemums by a Stream," 1765. (Library of Congress Prints and Photographs Division Washington, DC, USA. Reproduction no. LC-DIG-jpd-02303)

13 Kitagawa Utamaro (1753–1806), "Three Beauties of the Present Day" (*Toji san bijin*), from "Pictures of Beautiful Women" (*Bijin-ga*), published by Tsutaya Juabur, *c.* 1793. (Toledo Museum of Art, Toledo, OH, USA; direct source Wikimedia Commons)

17 Kitagawa Utamaro (1753–1806), "Okita of Naniwa-ya" (*Naniwaya Okita*), 1793. (Library of Congress Prints and Photographs Division Washington, DC, USA. Reproduction no. LC-DIG-jpd-02069)

21 Kitagawa Utamaro (1753–1806), "Comb" (*Kushi*), *c.* 1795–1796. (Library of Congress Prints and Photographs Division Washington, DC, USA. Reproduction no. LC-DIG jpd-02051)

25 Eishosai Choki (active 1789–1823), "Brazier" (*Hibachi*), *c.* 1794. (Library of Congress Prints and Photographs Division Washington, DC, USA. Reproduction no. LC-DIG-jpd-02059t)

29 Ikeda Eisen (1790–1848), "An Allegory of Komachi Visiting" (*Kayoikomachi no mitate*), *c.* 1818. (Library of Congress Prints and Photographs Division Washington, DC, USA. Reproduction no. LC- DIG-jp 02378)

33 Katushika Hokusai (1760–1849), "Woman in Blue Checked Kimono," 1830. (Library of Congress Prints and Photographs Division Washington, DC, USA. Reproduction no. LC DIG-jpd-02787)

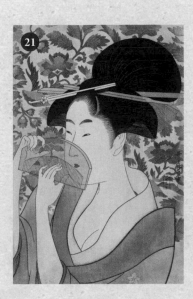
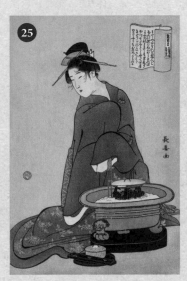
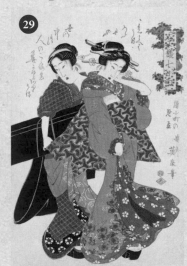
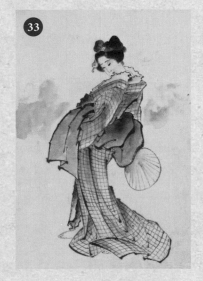

37 Yanagawa Shigenobu II (active 1824–1860), "Geisha Tuning a Shamisen" (*Te-ike no hana*), from the series "A Flower Competition" (*Hana-awase*), *c.* 1835. Color woodblock print: surimono. Gift of Carl Holmes (M.71.100.33) (Los Angeles County Museum of Art, Los Angeles, CA, USA; direct source Wikimedia Commons)

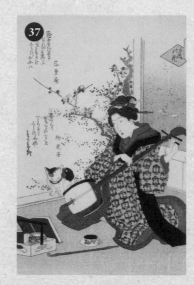

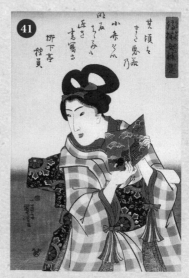

41 Utagawa Kuniyoshi (1798–1861), no. 9 in the series "Women as Benkei" (*Shuzoroi onna Benkei*), a.k.a. "Women in Benkei-checkered Kimono," published by Iba-ya Kyubei, 1844. (Wikimedia Commons)

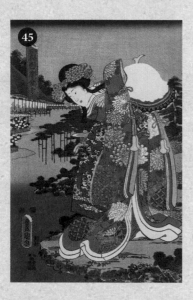

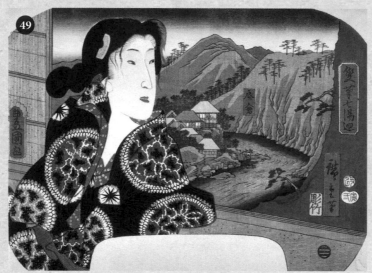

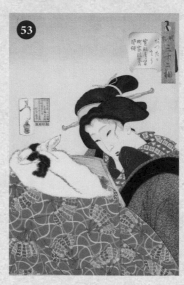

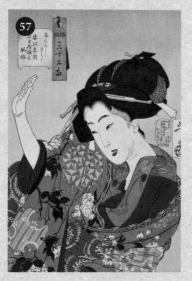

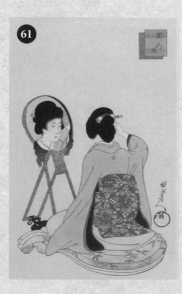

49 Utagawa Kunisada (Toyokuni III) (1786–1865) and Utagawa Hiroshige (1797–1858), "Hot Springs" (*Sokokura*), from the series "Two Artists Tour the Seven Hot Springs," 1854. (Fine Arts Museum of San Francisco, CA; direct source Wikimedia Commons)

53 Tsukioka Yoshitoshi (1839–1892), "Looking Warm: The Appearance of an Urban Widow of the Kansei Era (1789–1801)," no. 4 in the series "Thirty-two Aspects of Customs and Manners" (*Fuzoku Sanjuniso*), 1888. (Private collection)

57 Tsukioka Yoshitoshi (1839–1892), "Looking Disagreeable: The Appearance of a Nagoya Princess of the Ansei Era (1854–1860)," no. 23 in the series "Thirty-two Aspects of Customs and Manners" (*Fuzoku Sanjuniso*), 1888. (Private collection)

45 Utagawa Kunisada (Toyokuni III) (1786–1865), "Red" (*Aka*), from the series "Five Colors of Dyed Silk" (*Itsutsuginu iro no somewake*), a.k.a. "Costumes in Five Different Colors," *c.* 1847–*c.* 1852. Polychrome woodblock print on paper. Gift of R. B. and Meryl Bonney (M.86.326.5) (Los Angeles County Museum of Art, Los Angeles, CA, USA; direct source Wikimedia Commons)

61 Toyohara (Yoshu) Chikanobu (1838–1912), "Woman Applying Makeup," from "Fashions of the East" (*Azuma*), published by Fukuda Hatsujiro, *c.* 1896–1904. (Wikimedia Commons)

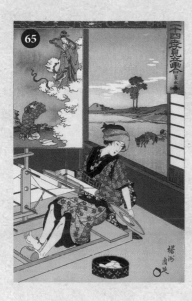

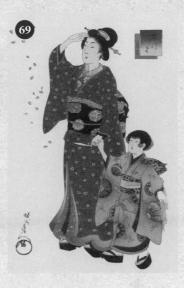

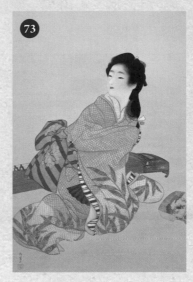

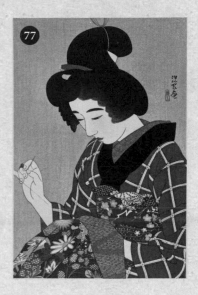

65 Toyohara (Yoshu) Chikanobu (1838–1912), from the series "Juxtaposed Pictures of Twenty-four Paragons of Filial Piety" (*Nijushi ko mitate e awase*), 1890. (Wikimedia Commons)

69 Toyohara (Yoshu) Chikanobu (1838–1912), "Cherry Blossom Viewing" (*Hanami*), from "Fashions of the East" (*Azuma*), published by Fukuda Hatsujiro, *c*. 1896–1904. (Wikimedia Commons)

73 Uemura Shoen (1875–1949), "Daughter Miyuki," 1914. (Adachi Museum of Art, Yasugi, Japan; direct source Wikimedia Commons)

77 Ito Shinsui (1898–1972), "Sewing" (*Hari Shigoto*), *c*. 1912–1925. (Library of Congress Prints and Photographs Division Washington, DC, USA. Reproduction no. LC-DIG jpd-02680t)

81 Kobayakawa Kiyoshi (1899–1948) ,"Pedicure" (*Tsume*), no. 3 in the series "Modern Fashionable Styles" (*Kindai jisei sho*), a.k.a. "Styles of Contemporary Make-up," 1930. (Wikimedia Commons)

85 Kobayakawa Kiyoshi (1899–1948), "Tipsy" (*Horo yoi*), no. 1 in the series "Modern Fashionable Styles" (*Kindai jisei sho*), a.k.a. "Styles of Contemporary Make-up," 1930. (Wikimedia Commons)

89 Ito Shinsui (1898–1972), "Snowstorm" (*Fubuki*), from the second series of "Modern Beauties" (*Gendai bijin shu dai-nishu*), 1932. (Private collection)

93 Uemura Shoen (1875–1949), "Composition of a Poem," 1942. (Wikimedia Commons)

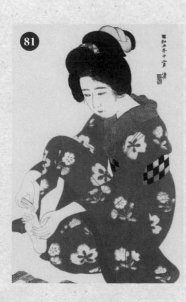

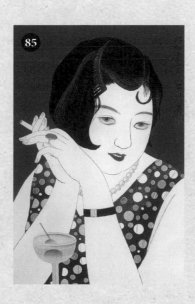

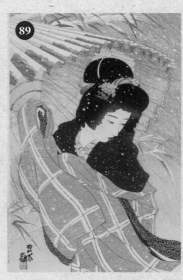

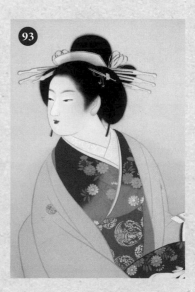

Women's Fashion and Lifestyle in Japanese Art

Japan has a long history of making woodblock prints and is especially renowned for its *ukiyo-e* ("pictures of the floating world"), a genre of Japanese woodblock prints and paintings produced from the mid-seventeenth century to the early years of the twentieth century. It is not certain when the technique of woodblock cutting was first introduced to Japan from China via Korea or when the first woodblock prints were made in Japan. In the eighth century, however, the woodcut technique was used to produce copies of religious texts for spreading knowledge of Buddhism in Japan. Then in several phases from about 1600 onwards the technique was used to produce secular book illustrations relating to poetry and novels and other educational purposes, such as instruction guides and travel books, and to *ukiyo-e*. The earliest printed pictures of the 1600s, confined to books and made from monochrome black *sumi* ink, gave way in the period 1720–1740 to delicately hand-colored prints using one or two pigments, usually light green and light red, then in 1745 to mass-produced color prints using two blocks, one for green, the other for red. The final phase, the mass-produced multicolored block-printed pictures that we now associate with Japanese printmaking, in particular *ukiyo-e*, began in the mid-1760s in Edo, the former name for Tokyo.

The Edo period (1603–1868), also called the Tokugawa period, was the final period of traditional Japan. Under the rule of the Tokugawa shogunate and the country's 300 regional feudal lords (*daimyo*), it was a time of internal peace, political stability, isolationist foreign policy, economic growth, rigid social order and enjoyment of arts and culture. After centuries of political unrest, the relative peace provided an ideal environment for the development of popular culture, including art in a commercial form. The rapid urbanization that took place in Japan in the late sixteenth century as a result of the declining influence of the warrior *samurai* class and the rise of a social class of *chonin* (literally "townspeople"), mostly merchants but also artisans, attendants of *daimyo* who were required to spend months in Edo, and other officials, also led to the secular development of woodblock printing in addition to theater, literature on urban life and culture and painted picture books.

The *chonin*, in theory the lowest social class under the Tokugawa shogunate, soon became the most powerful economically, a thriving merchant class who lived for the moment and had the money to indulge in a life of luxury and the pursuit of entertainment and relaxation free of the influences of the classicism of the nobility and the Confucianism of the *samurai* class. Much of their wealth and free time was spent in the licensed pleasure quarter of Edo, known as Yoshiwara, famed for its government-sanctioned brothels, *kabuki* theater, *sumo* wrestling, fashionable restaurants and teahouses, street entertainment and, of course, its beautiful women—courtesans (high-class prostitutes) and *geisha* (professional female

entertainers). Edo, by the early eighteenth century the largest city in the world with over a million inhabitants, was a magnet for artists, craftsmen, literati, entertainers and others tending to the needs of the newly wealthy merchant class. Not only were *ukiyo-e* artists inspired by Edo's "floating world" of pleasure and entertainment, monied patrons were eager to acquire the vivid images they created of celebrated actors and beauties. The middle-class merchants thus had a hand in influencing the subject matter of *ukiyo-e*, which developed along three main themes—*kabuki* actors, landscapes (but only after travel had become a leisure pursuit) and beautiful women (*bijin*).

The making of *ukiyo-e* prints was a collaborative effort between the artist, woodblock carver, printer and publisher. Artists rarely carved their own woodblocks for printing. Rather, production was divided between the artist who designed the

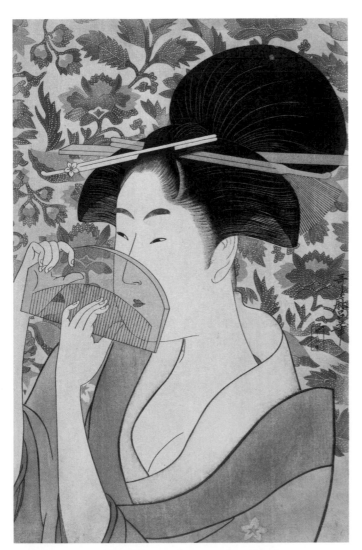

Kitagawa Utamaro (1753–1806), "Comb" (*Kushi*), *c.* 1795–1796

prints, the carver who cut the woodblocks, the printer who inked and pressed the woodblocks onto hand-made paper and the publisher who financed, promoted and distributed the works. As printing was done by hand, printers were able to achieve effects impractical with machines, such as the blending or gradation of colors on the printing block. Initially, most *ukiyo-e* were created as posters advertising local entertainment, such as theater performances and wrestling and services offered by teahouses, restaurants, bars and brothels. Many carried portraits of popular actors and beautiful women from the pleasure quarter, including courtesans standing in front of an establishment with their names emblazoned on the awning. Some *ukiyo-e* were commissioned as souvenirs for satisfied clients, often in the form of flat fans bearing portraits of the most beautiful courtesans. Companies also promoted their goods, such as *saké*, by commissioning prints of beautiful women posing with the company's products.

Because the costumes, hairstyles, make-up and poses used in *kabuki* theater remained relatively static during the Edo period, the style in which actors are characterized in *ukiyo-e*, including the generic "big head" portrait, did not change significantly. Likewise, the depiction of landscape, with its reliance on imagination, composition and atmosphere rather than on strict observance of nature or attention to realistic perspective, remained largely as a background to central figures until late in the Edo era. In contrast, the portrayal of women in *ukiyo-e* changed radically during the Edo period as classical Japanese aesthetics merged with contemporary urban themes to celebrate the hedonistic "floating world" inhabited by *geisha* and courtesans.

Bigin-ga, or "images of beauty" in *ukiyo-e*, portray both real and idealized women. Initially, *ukiyo-e* prints featured high-ranking courtesans but soon came to include *geisha*, lower-ranking courtesans, notable townswomen, historic figures and ordinary women. The women are depicted alone, in pairs or in groups, in different activities and occupations and in private and public settings, but always surrounded by an aura of beauty. In the prints in this book, they are shown

reading (p. 54), composing poetry (p. 94), playing the *shamisen* three-string lute (p. 38), performing their toilette—applying make-up, dressing their hair (pp. 22, 62) and having a pedicure (p. 82)—in preparation for an evening in the amusement quarter, sewing a kimono (p. 78), serving tea (p. 18), tending to a *hibachi* brazier (p. 26) and walking through the streets alone or with an attendant (p. 30) or child (p. 70). Sometimes they are depicted against scenery (pp. 10, 46, 50). In an unusual *ukiyo-e*, a rural woman is shown sitting at her loom weaving (p. 66).

In the earliest secular depictions of Japanese women in scrolls illustrating epic stories of the time, such as the eleventh-century *Genji Mono-gatari* (The Tale of Genji) by Murasaki Shikibu, women's faces are invariably plump, with rounded cheeks, high foreheads, heavy eyebrows, small vermilion mouths and noses drawn with a hook-shaped line. In the seventeenth century, with the introduction of *ukiyo-e*, women's portraits began to be imbued with greater realism. Changing ideas of feminine beauty led to prints illustrating statuesque women, full-bodied women, waif-like girls, robust characterful women and other types. Always there is a focus on the female form, on elaborately coiffed hair held up with costly hair ornaments to expose the nape of the neck, and

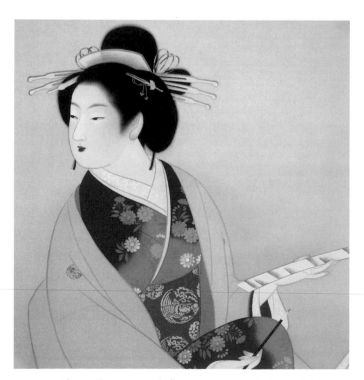

Uemura Shoen (1875–1949), "Composition of a Poem," 1942

on intricately patterned kimono or other dress appropriate for their occupation. Although the women portrayed are beautiful and graceful, their poses are somewhat stereotyped. There was a tendency to pose beauties in what was called the "serpentine posture" in which the subjects' bodies are twisted unnaturally while they face behind.

Despite their low status in the rigid social hierarchy of the Edo period, courtesans and actors became the style icons of the day. Their fashions could be almost instantly captured in *ukiyo-e* and were disseminated to the general fashion-conscious public via inexpensive, usually single-sheet woodblock prints that showed beauties modeling the latest hairstyles, accessories, cosmetics and textile designs. Because the prints were cheap and easily accessible, they were enormously influential. Many of the *kimono* in the courtesan portraits were, in fact, designed by the print artist, and textile designers would purchase the prints to glean ideas for similar designs on fabric. Thanks to the rapidly increasing level of literacy as well as the growing affluence of urban Japanese, single-sheet *ukiyo-e* also became extremely popular as a cheap way of decorating homes—pasted on walls, pillars, sliding doors and blank folding screens, or hung as scrolls in alcoves.

The *ukiyo-e* artists featured in this coloring book range from those who worked in the late eighteenth to early nineteenth century (Harunobu, Utamaro, Choki and Eisen), those active from the 1820s to the late nineteenth century (Chikanobu, Hokusai, Shigenobu, Kuniyoshi, Kunisada, Hiroshige and Yoshitoshi), and relative latecomers from the early to the mid-twentieth century (Shoen, Shinsui and Kiyoshi). All tended to work in larger, vertical formats and almost all portray a single female figure, at times with an attendant. All adhered to the characteristic feature of most *ukiyo-e* prints—well-defined, bold, flat lines—and many used a rich palette of tones. Thick curvilinear lines define the pose of the women in contrast to the very fine lines that describe the features of their heads, hands and feet. Most figures are arranged in flat spaces, with attention being drawn to vertical and horizontal relationships and details such as lines, shapes and patterns.

Suzuki Harunobu

(1725–1770)

"Transformation of Kikujiro" (*Yatsushi Kikujiro*), also known as
"Collecting Chrysanthemums by a Stream," 1765

Suzuki Harunobu, an Edo-born artist, was one of the large group of woodblock print artists whose work was devoted to the portrayal of scenes from the Yoshiwara, the entertainment district of Edo (modern Tokyo). He also produced many *mitate-e*, parody pictures with classical themes given a modern twist, and *shunga* (erotic prints). Harunobu was the first artist in the *ukiyo-e* style to produce, in 1765, full-color prints (*nishiki-e*), over which he developed great technical mastery. These effectively replaced the former two- and three-color prints. Most of Harunobu's pictures of beautiful women (*bigin-ga*) display graceful, slender, somewhat childlike figures who lack individuality or personality. He was a master of composition and was more concerned with setting his subjects in a pure, idealized environment than with drawing attention to any one element, such as a woman's face or her kimono. His works are full of color, often with solid backgrounds. This print is a parody picture (*mitate-e*) based on the Chinese legend of an ancient Chinese wizard, Ju Citong (Kikujiro), who is forced into exile where he learns the secret of eternal life. He is shown in the guise of a beautiful girl picking chrysanthemums besides a flowing brook. The portrayal of a single figure in a horizontal composition, most often used for large groups of people or landscapes, was rare at the time.

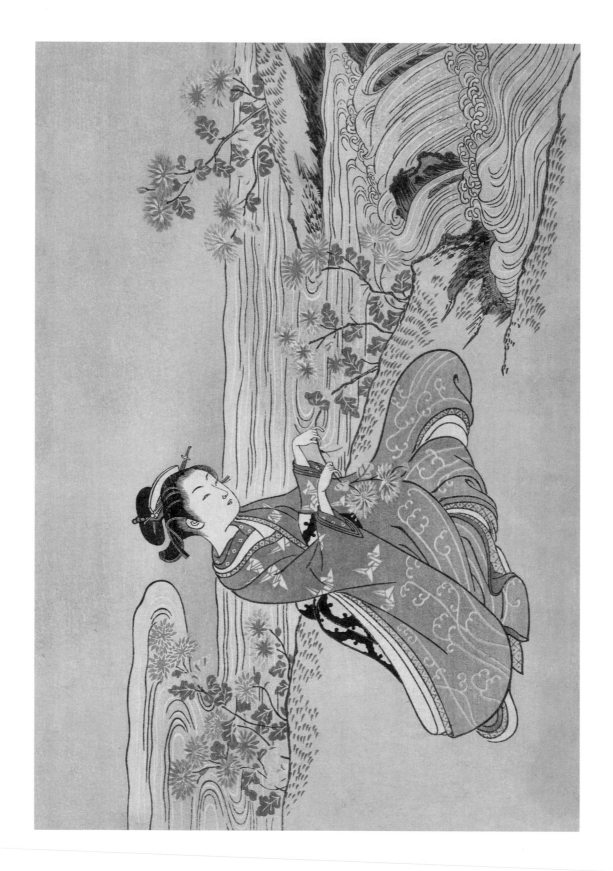

Suzuki Harunobu (1725–1770), "Transformation of Kikujiro" (*Yatsushi Kikujiro*), a.k.a. "Collecting Chrysanthemums by a Stream," 1765

Suzuki Harunobu (1725–1770), "Transformation of
Kikujiro" (*Yatsushi Kikujiro*), a.k.a. "Collecting
Chrysanthemums by a Stream," 1765

Kitagawa Utamaro

(1753–1806)

"Three Beauties of the Present Day" (*Toji san bijin*), from
"Pictures of Beautiful Women" (*Bijin-ga*), *c.* 1793

Kitagawa Utamaro is an icon in Japanese culture. He dedicated his whole life to exploring female beauty and in the 1790s, the "golden age" of printmaking, was the leading *ukiyo-e* artist in the *bijin-ga* genre of beautiful women. Initially, Utamaro focused on "large head" (*bigin-ga okubi*) three-quarter profiles of women before turning to single full-figure portraits. Unlike the stereotyped figures in the works of his predecessors, Utamaro was able to capture aspects of the personalities and moods of women of all ages, classes and occupations through subtle differences in the shapes of their faces, eyes, noses and mouths. This triangular composition, a traditional arrangement popular in the 1790s, depicts three famous beauties of Edo—Tomimoto Toyohina (back), a *geisha* in the Yoshiwara pleasure district well-known for her playing of the *shamisen*, a three-stringed lute, and two waitresses, both daughters of teahouse owners, Takashima Hisa (left), holding a hand towel over her shoulder that partly obscures her family's three-leaved oak *daimyo* crest, and Naniwa Kita (right), holding a hand fan (*uchiwa*) printed with her family emblem. Each has jet-black hair with fine white lines in front done up in the fashionable Shimada style popular at the time, which exposes their long, curved necklines. Toyohina is dressed in a showier *geisha*-style kimono with a primrose crest on her sleeve, while the two homelier teahouse waitresses wear black patterned kimono reminiscent of tie-dye *ikat* fabric (*shibori*). Typical of *ukiyo-e*, bolder curvilinear lines define their poses and clothing while fine lines describe their faces and hands.

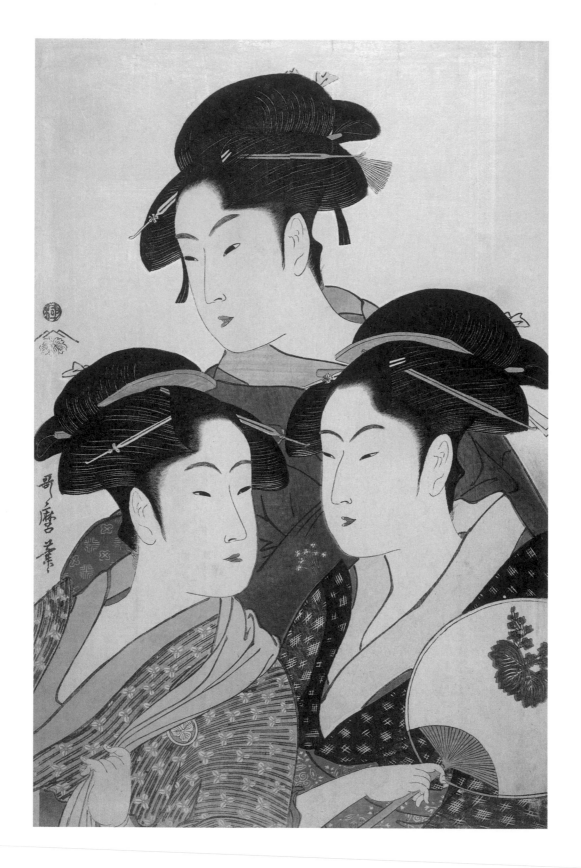

Kitagawa Utamaro (1753–1806), "Three Beauties of the
Present Day" (*Toji san bijin*), from "Pictures of
Beautiful Women" (*Bijin-ga*), *c.* 1793

Kitagawa Utamaro (1753–1806), "Three Beauties of the
Present Day" (*Toji san bijin*), from "Pictures of
Beautiful Women" (*Bijin-ga*), *c*. 1793

Kitagawa Utamaro

(1753–1806)

"Okita of Naniwa-ya" (*Naniwaya Okita*), 1793

Kitagawa Utamaro became the undisputed master of the genre of *bigin-ga okubi* (large heads of beautiful women) in the 1790s. His subjects were not courtesans, as was expected in *ukiyo-e*, but young women, some still in their mid-teens, who were known around Edo for their beauty. The three models in "Three Beauties of the Present Day" (*Toji san bijin*) (p. 13) appeared in numerous other portraits by Utamaro and other artists, including Naniwa-ya Okita (the Naniwa Kita of "Three Beauties of the Present Day"), shown in this print, the well-known daughter of the owner of the Naniwa-ya teahouse at Asakusa near the Senso-ji temple, where she worked attracting customers. In line with his preoccupation with depicting women in their most characteristic surroundings or circumstances, Utamaro shows Okita in three-quarter profile holding a cup of tea, presumably for serving to a customer. She turns to glance at someone just outside the picture, giving her figure, although stationary, a sense of movement. Unlike his close-up "big head" portraits, this single-sheet print is a "half-torso" depiction focusing on the face and upper half of the body. Okita wears a green kimono with a red under-kimono (*nagajuban*), both with dyed repeat motifs, and a greenish-yellow sash (*obi*) with fine yellow stripes. Her hair is beautifully drawn, especially the white lines in front.

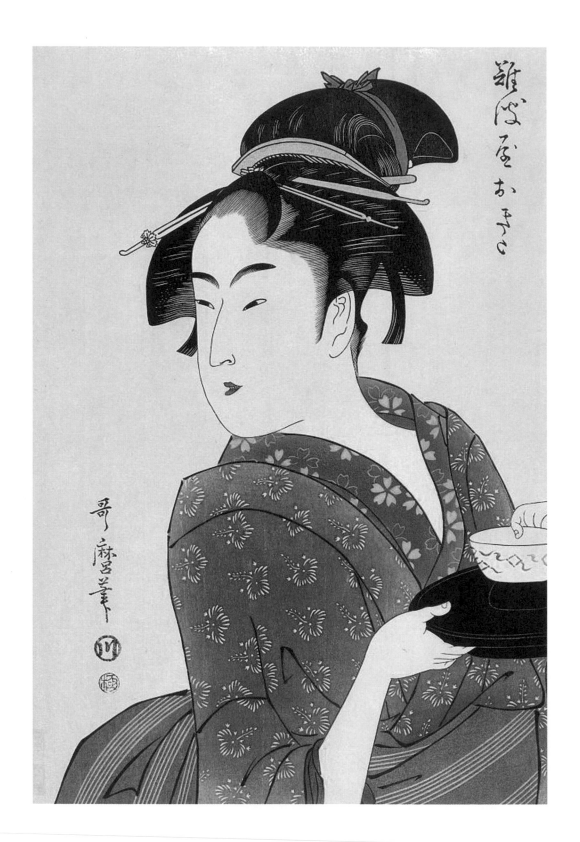

Kitagawa Utamaro (1753–1806), "Okita of Naniwa-ya"
(*Naniwaya Okita*), 1793

Kitagawa Utamaro (1753–1806), "Okita of Naniwa-ya"
(*Naniwaya Okita*), 1793

Kitagawa Utamaro

(1753–1806)

"Comb" (*Kushi*), c. 1795–1796

Kitagawa Utamaro is particularly celebrated for his ability to capture the individuality of his *bijin-ga* (beautiful women) in all their moods. In this "large head" woodblock print (*bijin-ga okubi*), which focuses on the head and upper torso, a woman looks through a transparent comb, most likely made of glass, which she has not yet inserted in her hair, usually near the top in front of the bun. Her lower face can easily be seen through the comb. Combs and hairpins, collectively called *kanzashi*, came into wide use during the Edo period when hairstyles became larger and more complicated and required more ornaments to secure the hair in place. During the latter part of the Edo period, the craftsmanship of *kanzashi* reached a high point, as the comb in this print illustrates. It is likely that the subject of this *ukiyo-e* was a popular beauty in Edo in the late 1790s by the name of Oshima. This can be surmised from an *uchiwa* hand fan painting similar to this print which Utamaro made about 1802–1803, inscribed with the name "Giyaman Oshima" (Glass Oshima). Unusual in Utamaro's work is the colorful floral background in this print, which resembles wallpaper. It forms a stark contrast to the plain, gauze-like fabric of the woman's kimono. Printed by hand with multiple woodblocks—one for each color—both the background and the woman are outstanding for the quality of their execution.

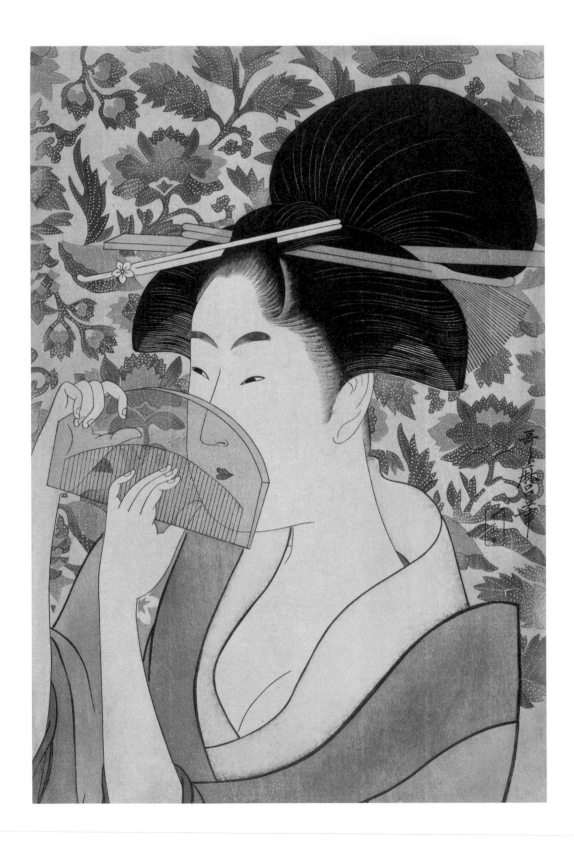

Kitagawa Utamaro (1753–1806), "Comb" (*Kushi*), *c.* 1795–1796

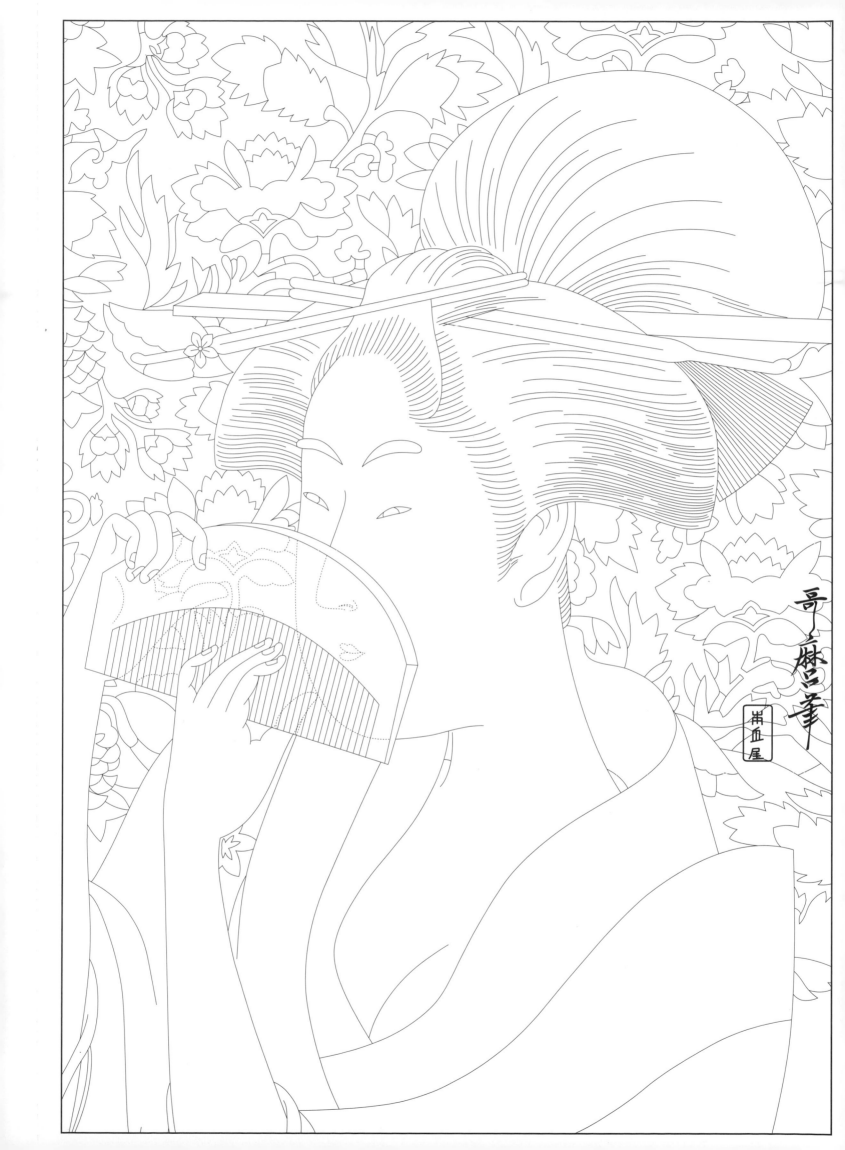

Kitagawa Utamaro (1753–1806), "Comb" (*Kushi*), *c.* 1795–1796

Eishosai Choki

(active 1789–1823)

"Brazier" (*Hibachi*), *c.* 1794

Although Eishosai Choki produced a relatively small number of woodblock prints compared with his contemporaries, nor was he as creative, he acquired a notable reputation as a *ukiyo-e* artist for a particular style of representing figures and for his often outstanding printing techniques. He is best known for his pictures of beautiful, slender women clad in colorful kimono, portrayed in a refined manner against a solid background. They are usually placed upright in the middle of a print or to one side. The women's backs are invariably straight, even rigid, and the curves of their bodies simple as they go about their particular task. The verticality of their bodies is counterbalanced by the sweep of their kimono which pools horizontally at the bottom of the print. There is contentment on their faces, even a small smile. In this print, a devoted housewife tends a covered pan on a brazier or *hibachi* (literally "fire bowl"), a traditional heating device consisting of an open-topped container made from a heatproof material designed to hold burning charcoal. She is holding a pair of irons used to light the fire in the *hibachi*. Her outer kimono is patterned below the waist with a chrysanthemum-type floral pattern.

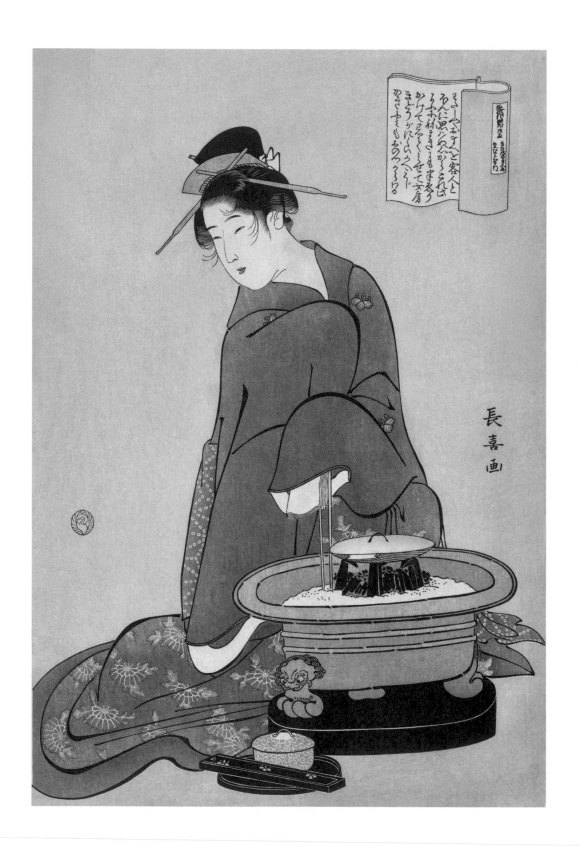

Eishosai Choki (active 1789–1823), "Brazier" (*Hibachi*), c. 1794

Eishosai Choki (active 1789–1823), "Brazier" (*Hibachi*), *c.* 1794

Ikeda Eisen (Keisai Eisen)
(1790–1848)
"An Allegory of Komachi Visiting" (*Kayoikomachi no mitate*), *c.* 1818

Towards the end of the Edo period (1603–1868), during the so-called "decadent" Bunsei era (1818–1830), there was a drastic change in the way woodblock print artists portrayed female beauty, from one that evoked idealized beauty to a more direct, realistic approach. The three "decadents" most active at this time—Ikeda Eisen, Utagawa Kuniyoshi (p. 41) and Utagawa Kunisada (p. 45)—were all immersed in Yoshiwara, the entertainment quarter of Edo, and thus the women in their prints are mostly beauties and courtesans. Ikeda Eisen, also known as Keisai Eisen after his first mentor, is best known for his portrayals of women. He specialized in *bijin-ga* (pictures of beautiful women) and his large head and close-up bust portraits (*okubi-e*) as well as his full-length studies of women depicting the fashions of the time are considered masterpieces. Not only do the women appear less graceful and elegant than in prints by his predecessors, they are also more alive, more voluptuous and sensual. *Mitate* in the title can be loosely defined as a figurative visual language that conveys many layers of meaning—the equivalent of metaphor, allusion, allegory and parody in written language (see also p. 9). Often it involves a classic figure placed in a contemporary context. In this print, the Heian-period poet Ono no Komachi is represented by a nineteenth-century model in nineteenth-century dress—here Komachi, depicted full length, poised and facing right, with an attendant standing behind her carrying a long box, perhaps a writing box or maybe a portfolio.

Ikeda Eisen (1790–1848), "An Allegory of Komachi
Visiting" (*Kayoikomachi no mitate*), *c.* 1818

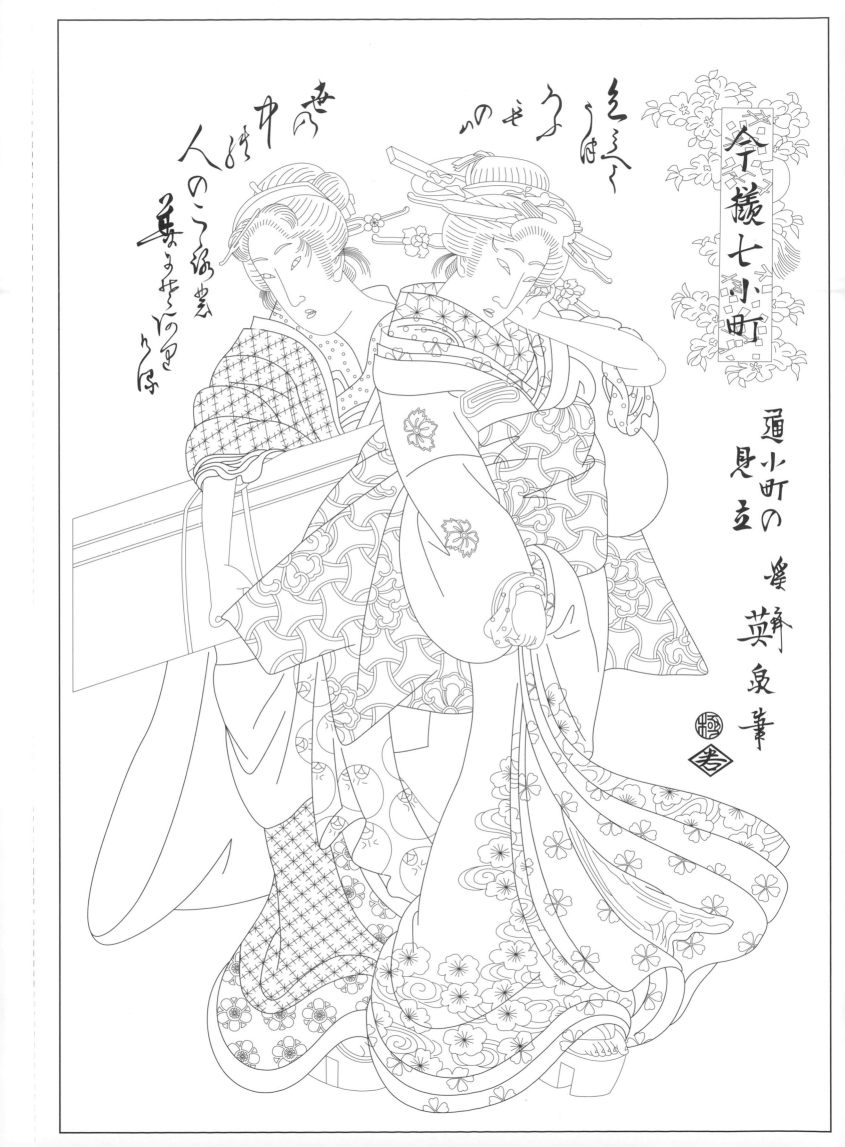

Ikeda Eisen (1790–1848), "An Allegory of Komachi
Visiting" (*Kayoikomachi no mitate*), *c.* 1818

Katushika Hokusai

(1760–1849)

"Woman in Blue Checked Kimono," 1830

Katushika Hokusai, artist, *ukiyo-e* painter and printmaker of the Edo period, was one of the most prolific artists the world has ever seen. He left over 30,000 works encompassing paintings, woodblock prints and printed albums. Of the countless books he illustrated, two in particular stand out—his three-volume *Thirty-six Views of Mount Fuji*, published in 1834 and 1835, which includes the internationally iconic print "The Great Wave of Kanaga," and his fifteen-volume *Hokusai Manga*, published between 1814 and 1834, which covers subjects ranging from flora and fauna to samurai, religious figures, the supernatural and the daily life and occupations of the Japanese. Above all, Hokusai transformed *ukiyo-e* from portraiture focused on actors and courtesans, the traditional subjects of *ukiyo-e*, into a much broader genre. His people are drawn with wit and humor. They also reveal his remarkable knowledge and understanding of the human figure. His people prints, such as the full-length standing portrait of the woman shown here, are notable for the quick and decisive way he could put complicated forms on paper. The lines and coloring also have a more painterly, less precise quality than most print artists, yet beautifully convey the essence of the subject. At the time, Hokusai was known to have used Berlin blue (*bero*), popularly known as "Prussian blue," imported from Europe, as well as traditional indigo to create subtle gradations in the blues of his prints.

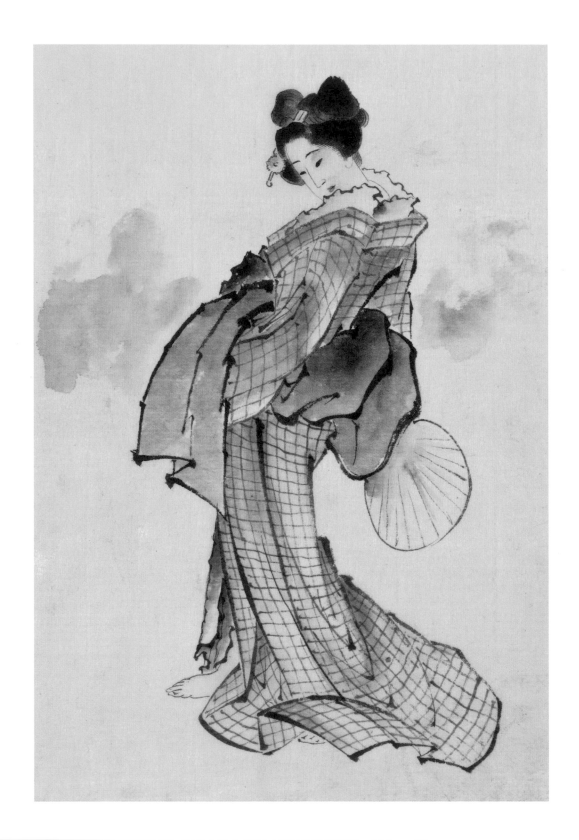

Katushika Hokusai (1760–1849), "Woman in Blue
Checked Kimono," 1830

Katushika Hokusai (1760–1849), "Woman in Blue
Checked Kimono," 1830

Yanagawa Shigenobu II

(active 1824–1860)

"Geisha Tuning a Shamisen" (*Te-ike no hana*), from the series
"A Flower Competition" (*Hana-awase*), c. 1835

Yanagawa Shigenobu II, who signed his illustrated verse anthologies Tanishiro Yanagawa or Yanagawa Juzan, assumed the name of his teacher Shigenobu I in the spring of 1933 after the latter died. In this print, a geisha tunes a *shamisen*, a plucked three-stringed lute, while reading a song book propped up against the handle of a tea box. She is seated in front of a screen (*byobu*) decorated with plum blossoms. A cat keeps her company. The courtesan's thick kimono and the plum blossom theme indicate a winter scene. To the left of the plum blossoms is a series of poems written in a poetic form called *kyoka* (literally "mad verse" but more like "playful verse"), which was popularized across all segments of society in Edo's "floating world." *Kyoka*, whose significance or meanings were often obscure, appeared in a new woodblock-printed form, surimono (literally "printed thing"), typically produced in a square format for a specific purpose, such as commemorating an event or offering greetings. Because the *kyoka* were written first, often in stylized calligraphy, the print artists would use the poems as a source of inspiration for their print designs. The title of this set refers to a poetry contest in which teams competed to produce the best poems about different flowers, although the "flowers" in the series probably refer to *bijin* (female beauties). This *surimono* may have been commissioned and privately published by members of a poetry group to promote their work or announce a poetry gathering or the winners of a poetry competition.

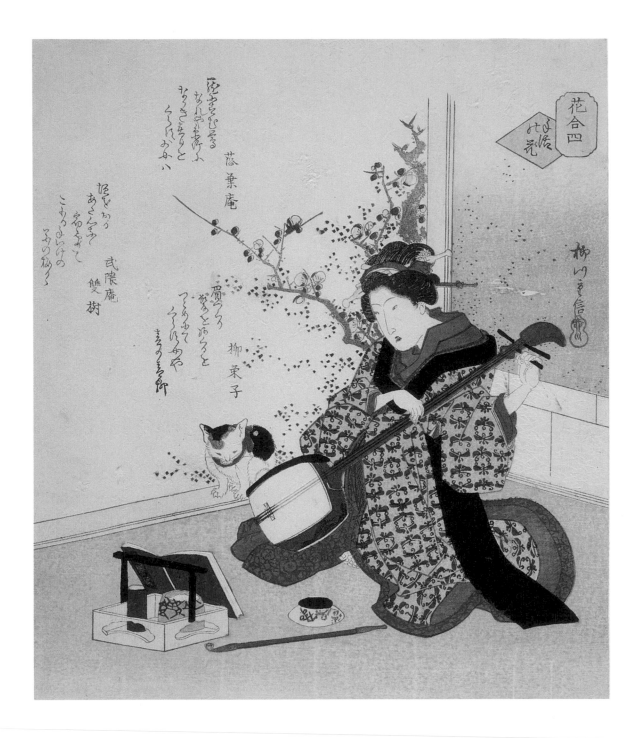

Yanagawa Shigenobu II (active 1824–1860), "Geisha Tuning a Shamisen" (*Te-ike no hana*), from the series "A Flower Competition" (*Hana-awase*), *c.* 1835

Yanagawa Shigenobu II (active 1824–1860), "Geisha Tuning a Shamisen" (*Te-ike no hana*),
from the series "A Flower Competition" (*Hana-awase*), *c.* 1835

Utagawa Kuniyoshi

(1798–1861)

No. 9 in the series "Women as Benkei" (*Shuzoroi onna Benkei*), also known as "Women in Benkei-checkered Kimono," 1844

Utagawa Kuniyoshi, the second of the so-called "decadent" print artists, was a member of the Utagawa school and one of the chief pupils of the famous print master Utagawa Toyokuni (1769–1825). His range of subjects encompassed many genre, including animals, historical subjects, warrior themes, landscapes and, after setting himself up as an independent artist, some remarkable pictures of beautiful women (*bijin-ga*). He depicted his women with large heads in relation to their bodies, which separated his work from that of earlier print artists. He also experimented with large textile patterns, including checks, and Western-style light-and-shadow effects. To circumvent the strict regulations put in place in the 1840s banning risqué subject matter in *ukiyo-e*, he produced caricature prints of actors, *geisha* and courtesans. He also created several series of beautiful women in the guise of famous characters of Japanese legend, such as the print here, one of a series of ten featuring beautiful women wearing *kimono* with a checkered pattern—a pattern associated with the legendary Japanese warrior monk Benkei, noted for his strength and loyalty to the famous warrior Minamoto no Yoshitsuni. Each print has a *kyoka* poem (see p. 37) referring to an event in Benkei's life or to one of the many fictionalized accounts of his life. In this print, a young woman looking over her right shoulder holds a traveling mirror with a large carp on its cover. Her *obi* sash is decorated with a Buddhist symbol alluding to Benkei dressed as a priest. The carp refers to the *Oniwakamaru to koi* (Oniwakamaru and the carp) episode. Benkei's childhood name was Oniwakamaru.

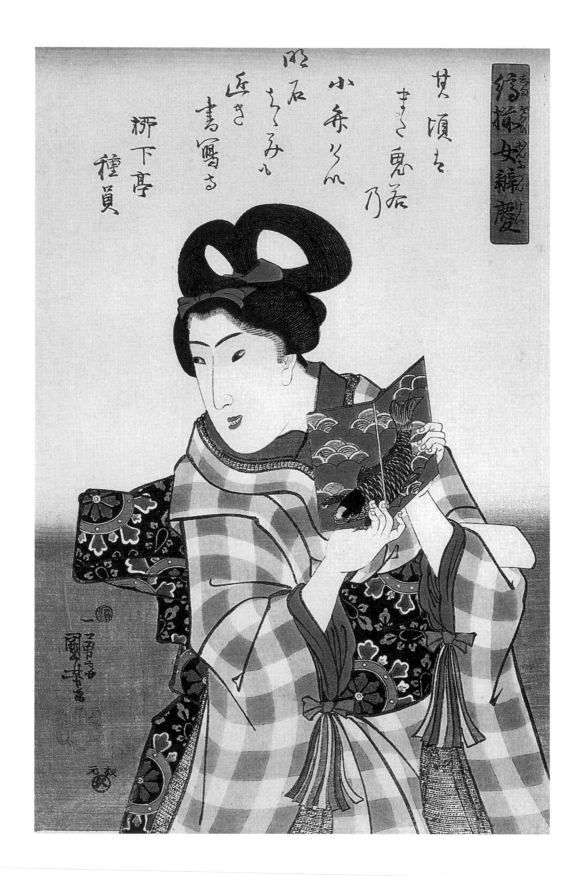

Utagawa Kuniyoshi (1798–1861), no. 9 in the series "Women as Benkei" (*Shuzoroi onna Benkei*),
a.k.a. "Women in Benkei-checkered Kimono," 1844

Utagawa Kuniyoshi (1798–1861), no. 9 in the series "Women as Benkei" (*Shuzoroi onna Benkei*),
a.k.a. "Women in Benkei-checkered Kimono," 1844

Utagawa Kunisada (Toyokuni III)
(1786–1865)

"Red" (*Aka*), from the series "Five Colors of Dyed Silk"
(*Itsutsuginu iro no somewake*), also known as "Costumes in Five
Different Colors," *c. 1847–c.* 1852

Like Utagawa Kuniyoshi, Utagawa Kunisada was an apprentice in the workshop of Toyokuni I (1769–1825). He eventually became head of the Utagawa school and took the name Toyokuni III. Like his mentor, his works fit into several categories of *ukiyo-e*. Initially an illustrator of woodblock printed picture books, his main output in the early years was *kabuki* and actor prints, followed by a series of *bijin-ga* (beautiful women), then portraits of *sumo* wrestlers. Kunisada was regarded as a trendsetter, in tune with the tastes of urban society. He continuously developed his style and was quick to exploit new techniques. He was also extraordinarily prolific, creating 30,000–40,000 individual print designs during his lifetime. In posture and appearance, Kunisada's women were different from his predecessors. His models were the same—courtesans, *geisha*, teahouse waitresses and the daughters of merchants drawn from the "floating world" of Edo—but they were shorter and fuller-figured, often with bent backs, giving them a stunted, bunched-up look. But for the first time, there are details on their faces, such as eyelashes and rouged cheeks, contributing to a sense of theatricality. They were invariably dressed in the latest kimono fashions, with striking textile patterns, forcing Kunisada to produce ever more prints to meet demand as the fashions dated. He frequently used the aniline color red (*ake*), as seen on the background of the kimono in this print, which is covered with bold chrysanthemum blossoms. Western-style shading and perspective are apparent in the background.

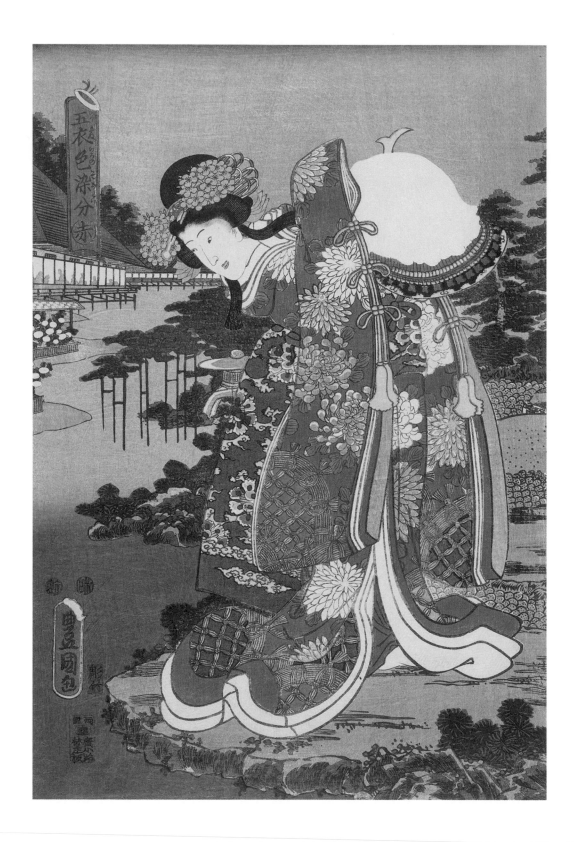

Utagawa Kunisada (Toyokuni III) (1786–1865), "Red" (*Aka*),
from the series "Five Colors of Dyed Silk" (*Itsutsuginu iro no somewake*),
a.k.a. "Costumes in Five Different Colors," *c.* 1847–*c.* 1852

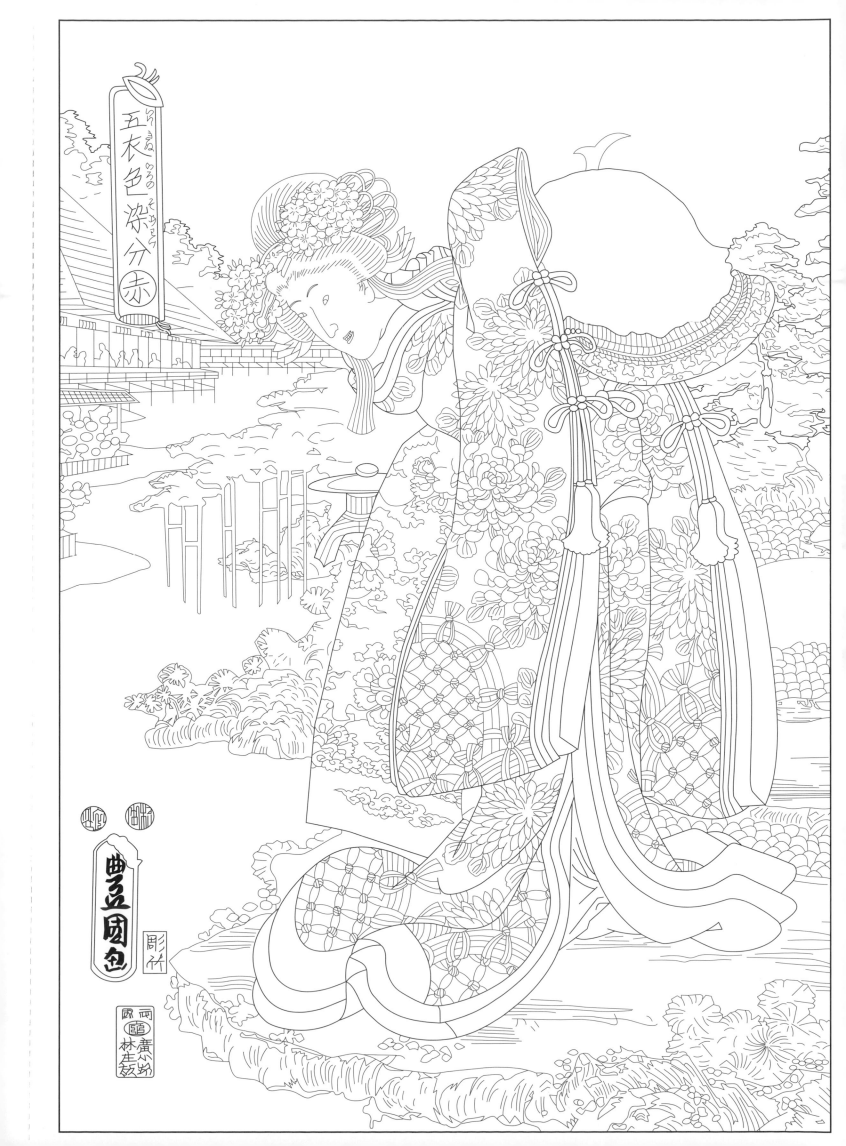

Utagawa Kunisada (Toyokuni III) (1786–1865), "Red" (*Aka*),
from the series "Five Colors of Dyed Silk" (*Itsutsuginu iro no somewake*),
a.k.a. "Costumes in Five Different Colors," *c.* 1847–*c.* 1852

Utagawa Kunisada (Toyokuni III)
(1786–1865)
and Utagawa Hiroshige
(1797–1858)

"Hot Springs" (*Sokokura*), from the series
"Two Artists Tour the Seven Hot Springs" (*Sohitsu shichito meguri*), 1854

Utagawa Kunisada (see p. 45), the last of his generation of woodblock artists, was one of the most popular and successful Japanese print artists of all time. Some of his series depicting women at work or leisure are among the finest of any in the "beautiful women" (*bijin-ga*) genre. Always at the vanguard of change in nineteenth-century Japan, and with a keen eye on what the public wanted, he constantly developed his artistic style and was not constrained by the approaches of his contemporaries. He was quick to exploit new techniques, such as creating more complex kimono designs in many colors and printing his works on heavier "deluxe" paper. He was aided by the skill of Edo's artisan craftsmen, which had reached unprecedented levels of sophistication by the mid-1850s. Although Kunisada hardly ever tackled landscapes, he did collaborate with Utagawa Hiroshige, one of two geniuses of landscape prints, the other being Katushika Hokusai (see p. 33), on the series "Two Artists Tour the Seven Hot Springs" in which a landscape serves as a backdrop for a figural composition. Importantly, the landscapes are views of specific places, not imaginary abstractions. The new Japanese leisure traveler liked to purchase prints of the locations they visited and mount them in albums. Sometimes they would purchase fans of the same scenes as souvenirs, such as this print in the fan format (*uchiwa-e*). In this collaborative print, Kunisada transitions from an emphasis on personal portraiture, while Hiroshige conveys atmosphere and a sense of realistic depth.

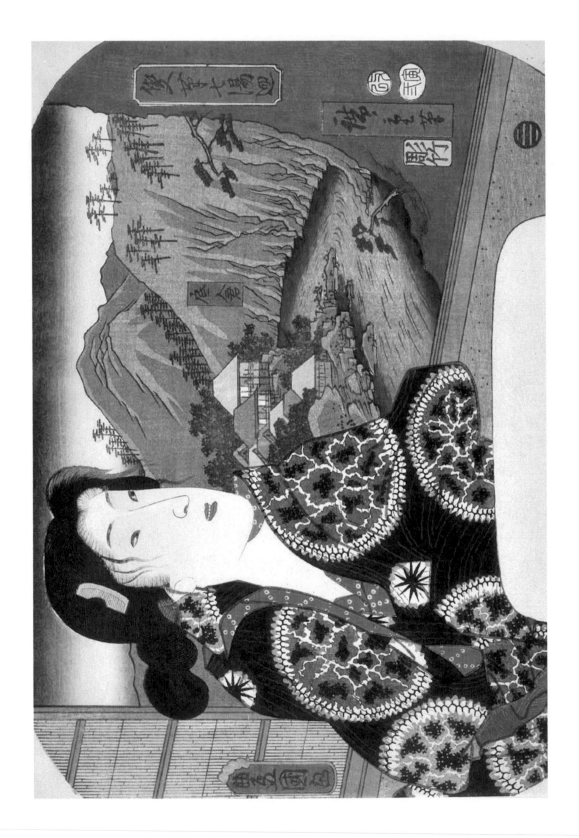

Utagawa Kunisada (Toyokuni III) (1786–1865) and
Utagawa Hiroshige (1797–1858), "Hot Springs" (*Sokokura*),
from the series "Two Artists Tour the Seven Hot Springs" (*Sohitsu shichito meguri*), 1854

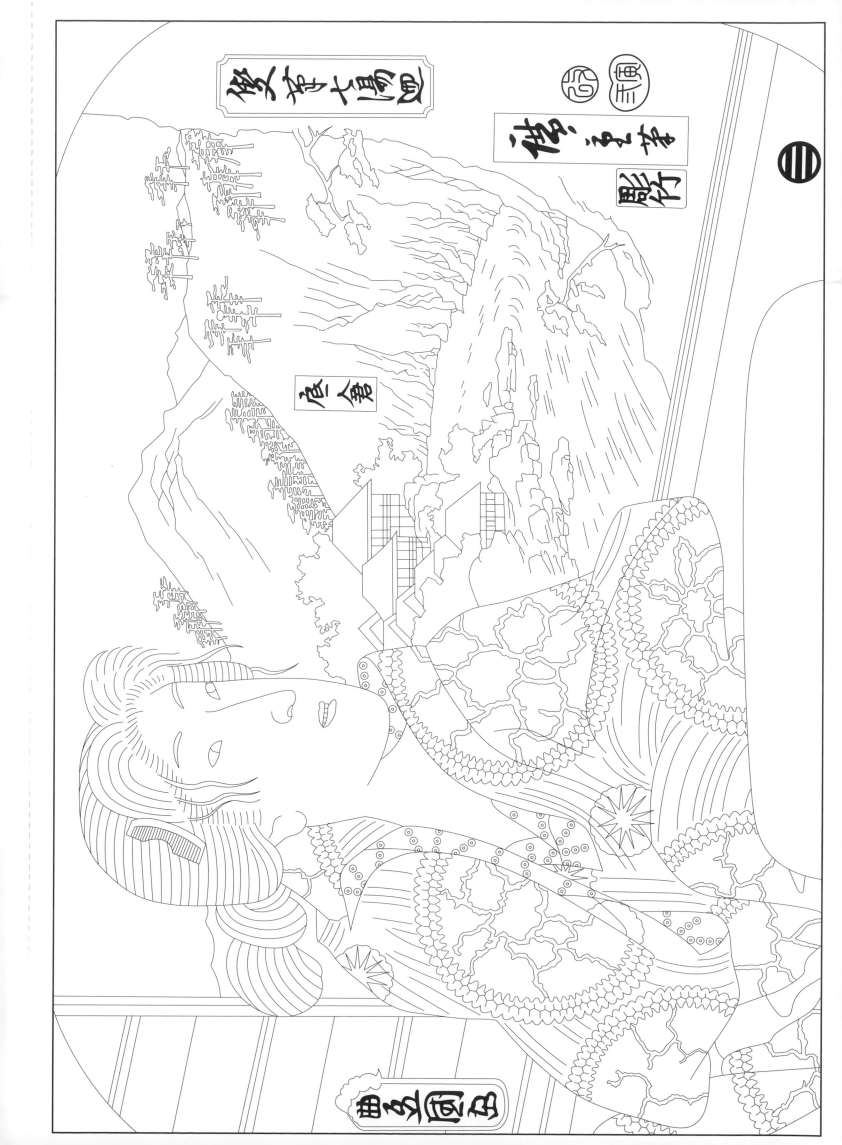

Utagawa Kunisada (Toyokuni III) (1786–1865) and
Utagawa Hiroshige (1797–1858), "Hot Springs" (*Sokokura*),
from the series "Two Artists Tour the Seven Hot Springs" (*Sohitsu shichito meguri*), 1854

Tsukioka Yoshitoshi

(1839–1892)

"Looking Warm: The Appearance of an Urban Widow
of the Kansei Era (1789–1901)," no. 4 in the series
"Thirty-two Aspects of Customs and Manners" (*Fuzoku Sanjuniso*), 1888

Tsukioka Yoshitoshi is widely recognized as the last great master of *ukiyo-e* woodblock printing and painting. His career spanned two eras—the final years of the Edo period and the first years of modern Japan following the Meiji Restoration—during which he struggled constantly with the tensions between Japanese tradition and encroaching Westernization. His prints represent traditional Japanese values. During his lifetime, Yoshitoshi produced many series of prints, the most famous being "One Hundred Aspects of the Moon" (1885–1892). His finest series of *bijin-ga*, "Thirty-two Aspects of Customs and Manners," comprises illustrations of beautiful women in a lighthearted reference to the thirty-two notable features of Buddha. In a chronological survey from the Kansei era (1789–1801) to the Meiji era (1860–1912), Yoshitoshi depicts women of different backgrounds and occupations, each associated with a particular mood or character trait. They are shown in a scene from daily life, realistically and sensitively portrayed as an individual rather than an idealized figure. Their kimono are beautifully rendered and their hairstyles and facial features are drawn with the finest of lines. The series was printed using the most costly techniques, such as delicate *bokashi* shading, embossing and burnishing, creating some of the finest prints of the Meiji era. In this intimate winter scene, a widow wrapped in a thick quilt is seated by a heated table (*kotatsu*) reading a book. Her eyebrows are shaved, the custom for married women, and tinted blue. Her cat is enjoying the warmth of the table.

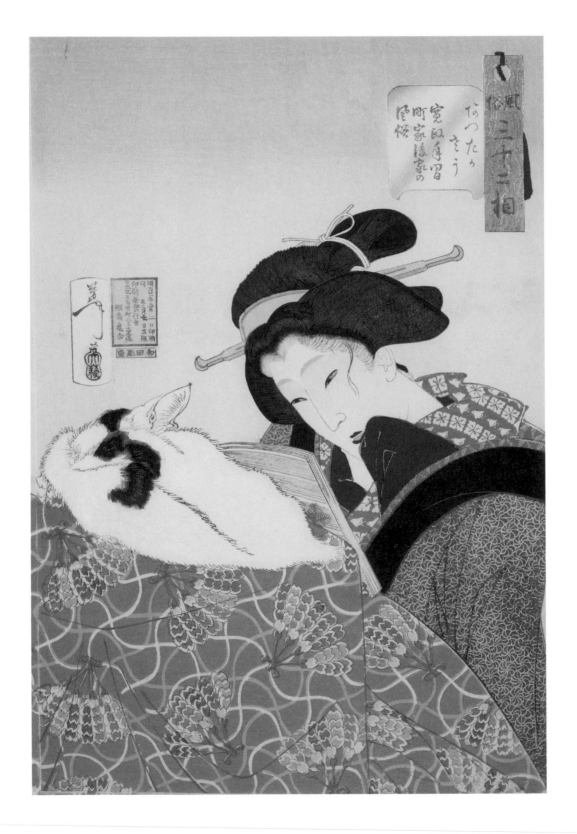

Tsukioka Yoshitoshi (1839–1892), "Looking Warm: The
Appearance of an Urban Widow of the Kansei Era (1789–1901)," no. 4 in the series
"Thirty-two Aspects of Customs and Manners" (*Fuzoku Sanjuniso*), 1888

Tsukioka Yoshitoshi (1839–1892), "Looking Warm: The
Appearance of an Urban Widow of the Kansei Era (1789–1801)," no. 4 in the series
"Thirty-two Aspects of Customs and Manners" (*Fuzoku Sanjuniso*), 1888

Tsukioka Yoshitoshi

(1839–1892)

"Looking Disagreeable: The Appearance of a Nagoya Princess of the Ansei Era
(1854–1860)," no. 23 in the series
"Thirty-two Aspects of Customs and Manners" (*Fuzoku Sanjuniso*), 1888

Tsukioka Yoshitoshi's series "Thirty-two Aspects of Customs and Manners" (see also p. 53) proved popular with the public when it was published in 1888, towards the end of Yoshitoshi's long career, and has been appreciated by viewers and collectors ever since. Designs in the series are some of the most sought-after woodblocks of the Meiji era and are considered great masterworks of Yoshitoshi's career. One interpretation of the title of this print is that it depicts a spoiled young lady rather than a real princess who, raising her hand, says "no" in a disagreeable way. Regardless, the print is remarkable for the extremely fine lines of the woman's face, with the lips slightly parted, the long, exposed nape of her neck and her full hairstyle. The complexity of the motifs on the woman's kimono and the fluidity with which the fabric drapes are the work of a master craftsman. The combination of red and green on the woman's lip, called *sasabeni* (red *beni* from the safflower and iridescent green *sasa* from the bamboo) was popular in the eighteenth and nineteenth centuries among prostitutes and fashionable ladies who wished to imitate this high-class look.

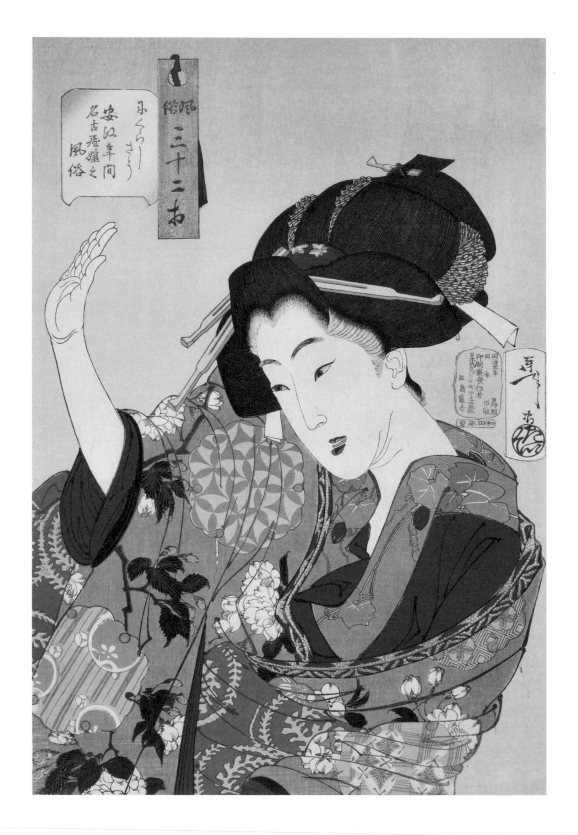

Tsukioka Yoshitoshi (1839–1892), "Looking Disagreeable: The Appearance of a
Nagoya Princess of the Ansei Era (1854–1860)," no. 23 in the series
"Thirty-two Aspects of Customs and Manners" (*Fuzoku Sanjuniso*), 1888

Tsukioka Yoshitoshi (1839–1892), "Looking Disagreeable: The Appearance of a Nagoya Princess of the Ansei Era (1854–1860)," no. 23 in the series "Thirty-two Aspects of Customs and Manners" (*Fuzoku Sanjuniso*), 1888

Toyohara (Yoshu) Chikanobu
(1838–1912)
"Woman Applying Makeup," from
"Fashions of the East" (*Azuma*), *c.* 1896–1904

Known to his contemporaries as Yoshu Chikanobu, Toyohara Chikanobu was a leading and prolific *ukiyo-e* artist of the Meiji period (1868–1912) at a time when Japan saw the reinstatement of the emperor as ruler and the country was undergoing rapid Westernization. He trained with the "decadents" Eisen, Kuniyoshi and Kunisada (see pp. 29, 41 and 45) and is probably the last of the true *ukiyo-e* artists. Although he produced prints over a wide range of subjects, both traditional and topical, he was known above all as a master of *bijin-ga*, images of beautiful women, dressed in clothing appropriate to their activities, pastimes and daily rituals. His prints not only capture the transition in women's fashion from the pre-Edo *samurai* era to the modern Meiji period but also changes in hairstyles and make-up. Chikanobu used the flat planes and decorative patterning of the *ukiyo-e* tradition to great effect, adding bright colors to his compositions, especially reds, purples and blues, and in this print apple green. He worked in a style that often reflected Western conventions in art. His work has been described as simultaneously retrograde and modern and the artist himself as both a master of nostalgia who focused on Japan's glorious past and the lost world of the shogunate and the forerunner of a new era of print artists.

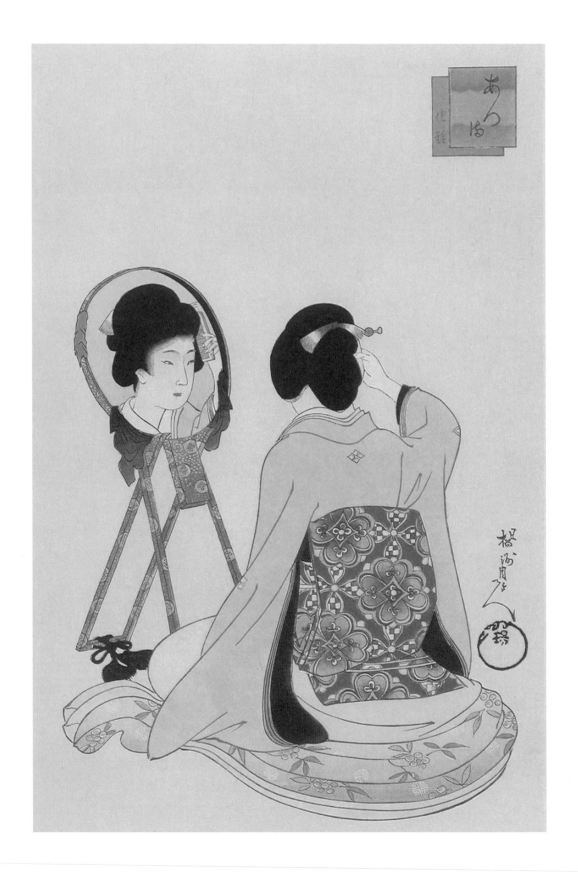

Toyohara (Yoshu) Chikanobu (1838–1912), "Woman Applying Makeup,"
from "Fashions of the East" (*Azuma*), *c.* 1896–1904

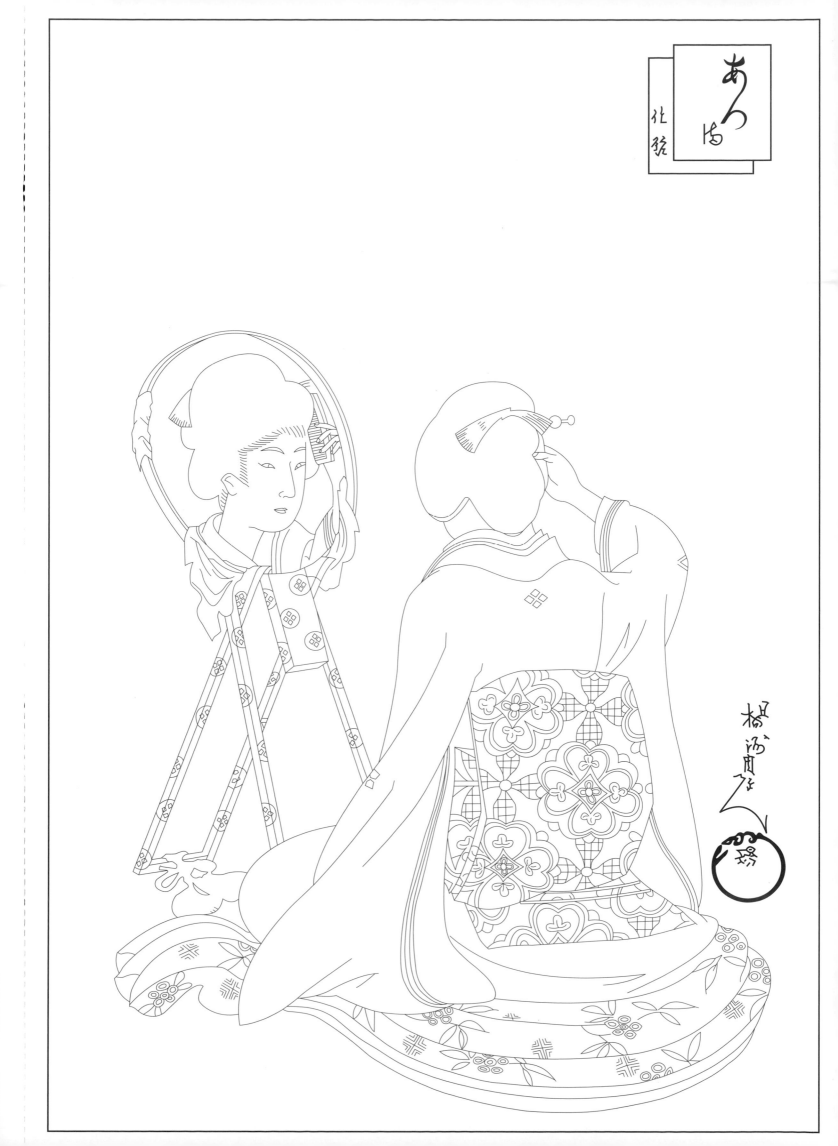

Toyohara (Yoshu) Chikanobu (1838–1912), "Woman Applying Makeup,"
from "Fashions of the East" (*Azuma*), *c.* 1896–1904

Toyohara (Yoshu) Chikanobu
(1838–1912)

From the series "Juxtaposed Pictures of Twenty-four Paragons of Filial Piety"
(*Nijushi ko mitate e awase*), 1890

Throughout the 1890s, Chikanobu produced single-sheet prints, diptychs and triptychs promoting traditional values and highlighting aspects of Japanese culture that were being forgotten. Among them, he created prints about filial piety to provide an alternative to what he and many contemporaries saw as the deterioration of Japanese society caused by imported ideas and modern methods. Chikanobu's last works in the early years of the twentieth century featured brave *samurai* and heroic women of Japan's past, models of appropriate behavior for the future. *The Twenty-four Paragons of Filial Piety* is a classic text of Confucian filial piety written by the Chinese scholar Guo Jujing during the Yuan dynasty (1260–1368). It recounts the self-sacrificing behavior of twenty-four sons and daughters who go to extreme lengths to honor their parents, step-parents, grandparents and in-laws. The book was extremely influential in the medieval Far East and was used to teach Confucian moral values. In this print, an inset (top left) depicts an example of Chinese filial piety through the story of Dong Yong, a young man who sold himself into servitude in order to afford a funeral that would honor his late father. In one version of the story, he meets and falls in love with a weaver maid. They marry and she helps him to pay his debt by weaving one hundred bolts of silk. In reality, she is a daughter of the Jade Emperor and was sent from Heaven to aid the pure-hearted young man. Having performed her task, she is called back to Heaven. The inset shows the moment of parting. In the center of the print, a contemporary image of a woman weaving is a figurative thread connecting the parable to everyday life.

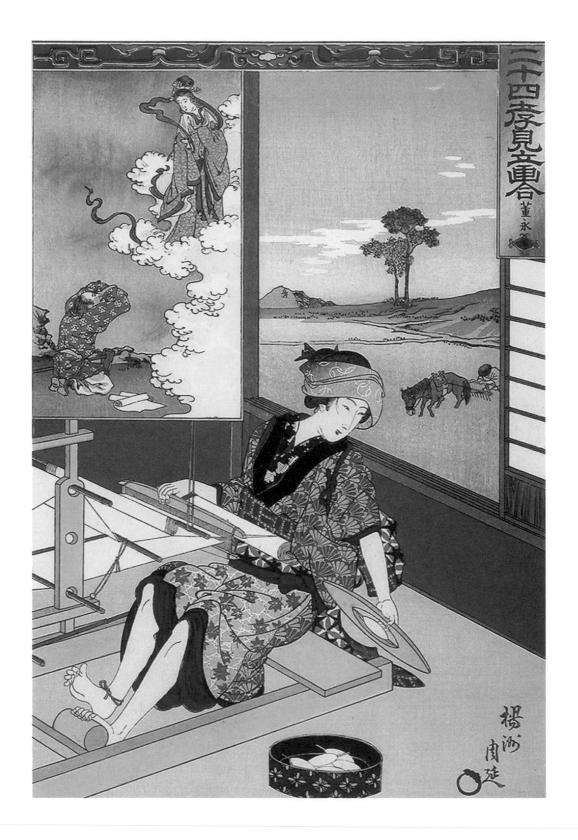

Toyohara (Yoshu) Chikanobu (1838–1912), from the series
"Juxtaposed Pictures of Twenty-four Paragons of Filial Piety" (*Nijushi ko mitate e awase*), 1890

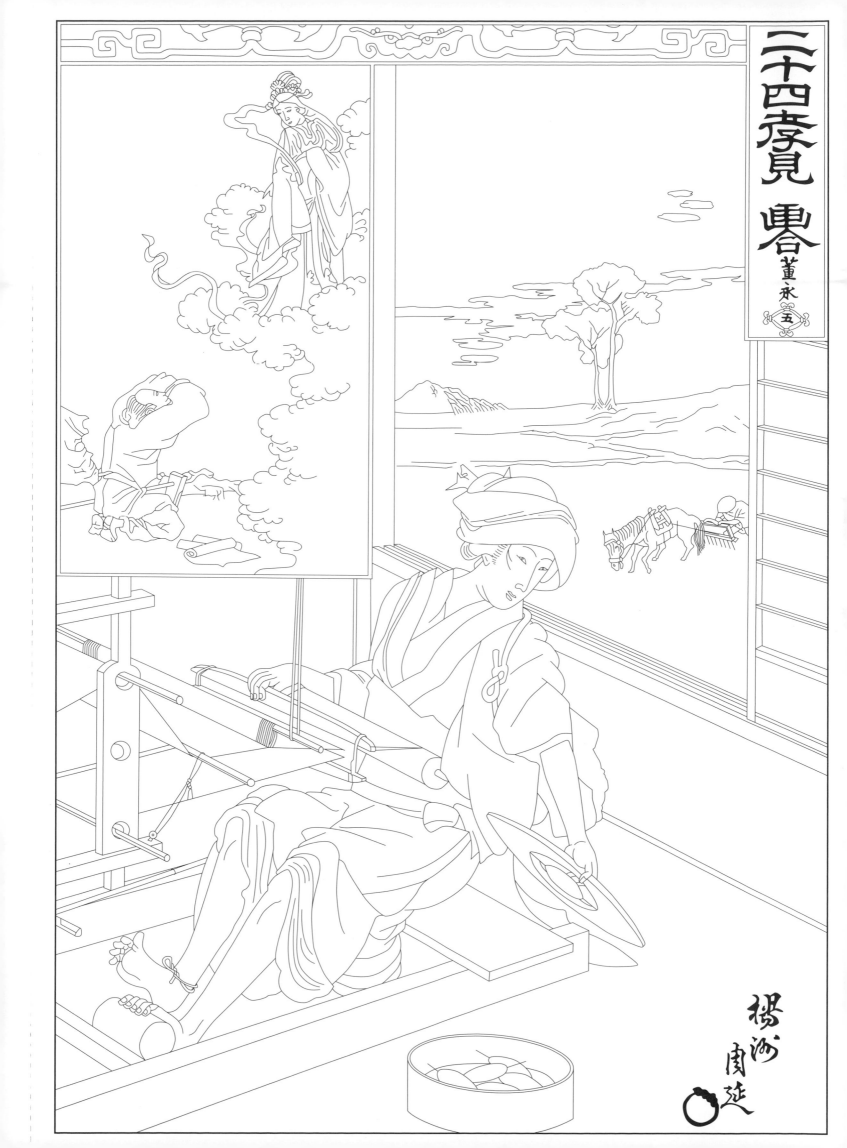

Toyohara (Yoshu) Chikanobu (1838–1912), from the series
"Juxtaposed Pictures of Twenty-four Paragons of Filial Piety" (*Nijushi ko mitate e awase*), 1890

Toyohara (Yoshu) Chikanobu
(1838–1912)
"Cherry Blossom Viewing" (*Hanami*), from "Fashions of the East"
(*Azuma*), c. 1896–1904

This woodblock print from the *Azuma* ("Fashions of the East") series (see also p. 61), depicts a woman holding her daughter's hand as they watch cherry blossoms fall (*hanami*) in early spring. The cherry blossom (*sakura*) is Japan's unofficial national flower—the chrysanthemum is its official flower—and is one of its most iconic symbols. For more than ten centuries, cherry trees and cherry blossom time have been deeply integrated in the history, culture and identity of Japan. While the Japanese delight in the lavish spectacle of cherry blossoms at their moment of greatest beauty, they also enjoy the sight of the delicate petals floating gently to the ground in spring breezes. The kimono of both mother and child are very skillfully executed and in great detail. The woman's outer kimono features five-petal cherry blossoms scattered over a blue, possibly indigo-dyed (*shibori*) background, while the child's kimono is printed with colorful *temari* handballs. *Temari* are sometimes displayed as ornaments during the Girls' Festival or given to children by their parents on New Year's Day. Both mother and daughter wear white socks split at the toe (*tabi*) and raised wooden clogs (*geta*) on their feet. The Meiji purple and the subtle shading of the girl's kimono are printmaking innovations.

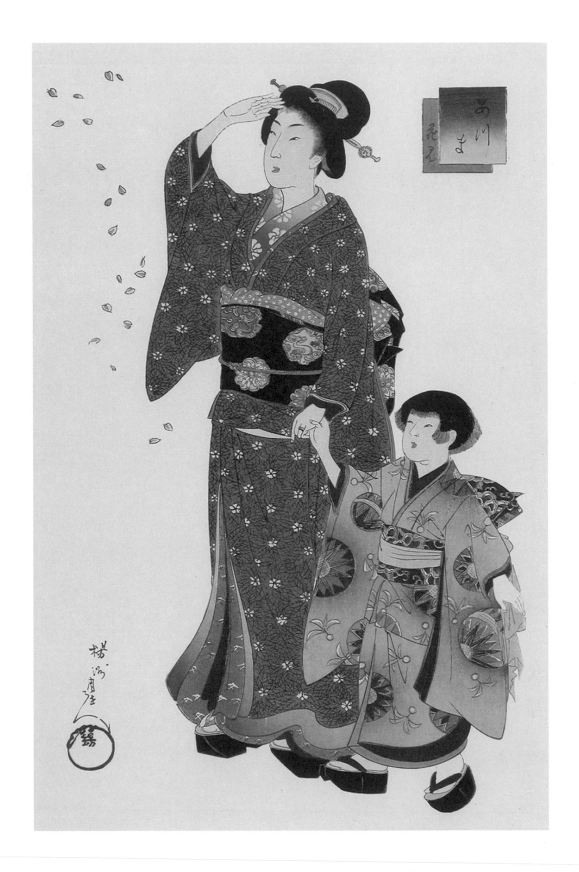

Toyohara (Yoshu) Chikanobu (1838–1912), "Cherry Blossom Viewing" (*Hanami*),
from "Fashions of the East" (*Azuma*), *c.* 1896–1904

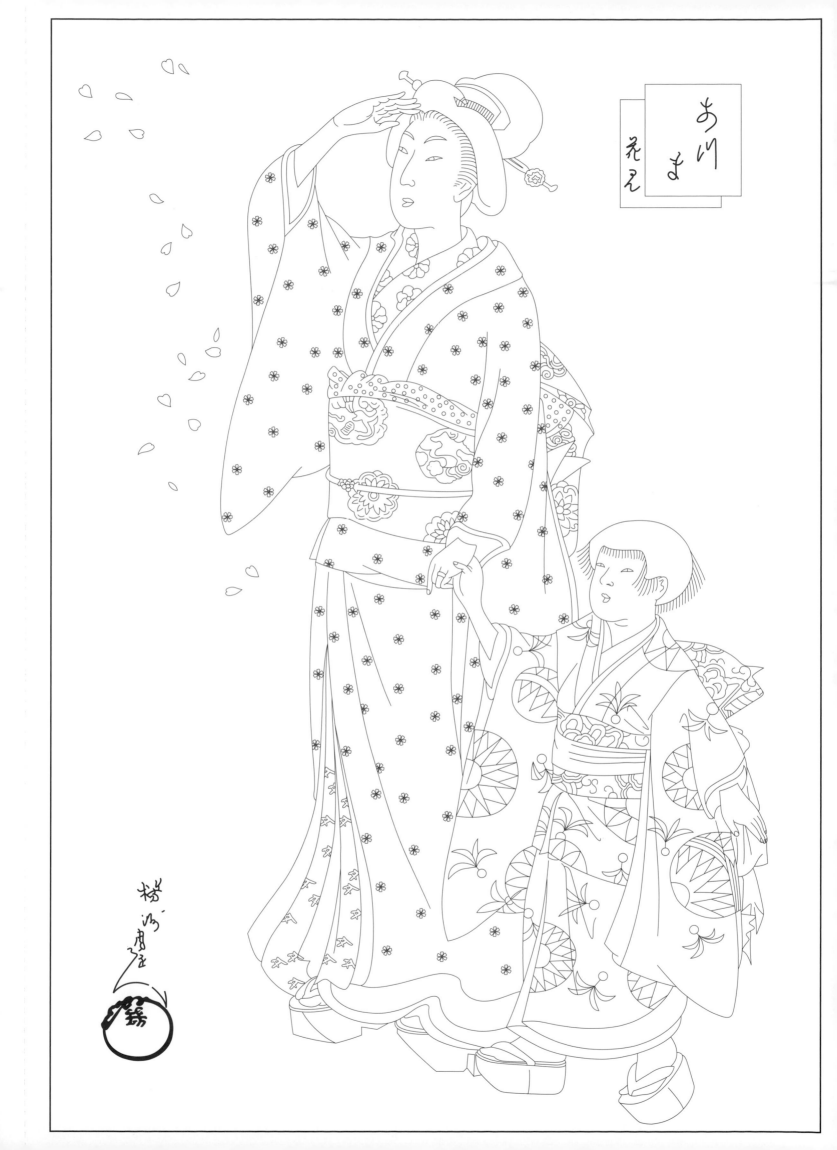

Toyohara (Yoshu) Chikanobu (1838–1912), "Cherry Blossom Viewing" (*Hanami*),
from "Fashions of the East" (*Azuma*), *c.* 1896–1904

Uemura Shoen

(1875–1949)
"Daughter Miyuki," 1914

Uemura Shoen was the pseudonym of Uemura Tsune, an important female artist whose work spanned three pre-war periods in Japan (1868–1945), the Meiji, Taisho and early Showa. She is known primarily for her beautiful women paintings (*bijin-ga*) in the *nihonga* Japanese style, which used traditional artistic conventions, techniques and materials. Uemura Shoen was just one of two women who achieved recognition for her work in her lifetime. She was appointed as official artist to the Imperial Household and was also the first woman to be awarded the Order of Culture for her contributions to Japanese art. The young woman in this painting on silk is Akizuki Miyuki, the heroine of an old ballad play (*jojuri*), *Sho-utsushi Asagao-banashi*. In this story, Miyuki was attacked by a bandit while gazing at fireflies but was saved by a man named Miyagi Asojiro before the bandit was able to assault her. The two fell in love and Asojiro sent Miyuki a fan with poetry written on it expressing his love for her. In this painting, Miyuki, sensing that someone is approaching while she looks at the fan quickly hides it in the sleeve of her kimono. Before the arrival of the love letter, Miyuki had been playing the *kota*, a traditional thirteen-string zither plucked using picks on the thumb and first two fingers of the right hand; the cover is on the right of the painting. Her fine checked kimono is decorated with bamboo leaves and her blue-striped *obi* sash with bold yellow chrysanthemums. The delicate painting of the face beautifully captures the heroine's youth and innocence.

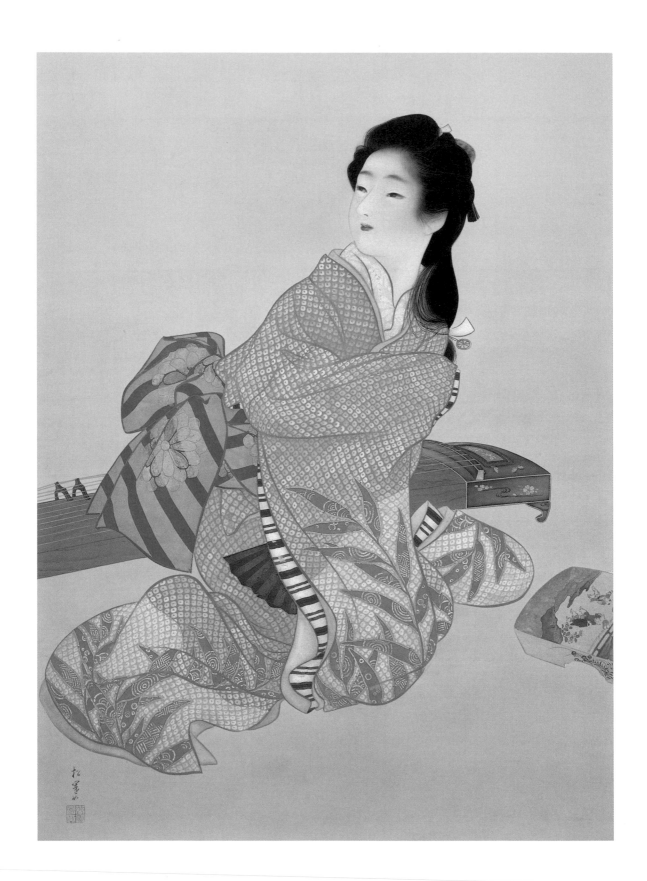

Uemura Shoen (1875–1949), "Daughter Miyuki," 1914

Uemura Shoen (1875–1949), "Daughter Miyuki," 1914

Ito Shinsui

(1898–1972)

"Sewing" (*Hari Shigoto*), *c.* 1912–1925

With the nineteenth century drawing to a close, a radical change occurred in the world of printmaking as well as in the method of drawing the female form as a print subject. As *ukiyo-e* began to fall out of fashion in the face of competition from Western lithography and photography, woodblock craftsmen were forced to turn to new print forms, including more realistic depictions of subjects. Woodblock prints created after 1915 are generally referred to as *shin hanga* ("new prints") and many were created by Watanabe Shozaburo, who started an export woodblock print business with a Western audience in mind. Ito Shinsui, who devoted his long life primarily to portraying the beauty of Japanese women, was among the transitional artists employed by Watanabe to revitalize the traditional art of printmaking. While focusing strictly on Japanese women, Ito Shinsui incorporated Western elements such as the use of shading to create subtle nuances in the features of his subjects. Eyelashes were drawn, hands became important, clothes and hair were less elaborate. In this print of a young woman in a blue checked kimono with a floral *obi* sewing a richly patterned red kimono, the drawing of the woman's nose, the subtle rendition of her mouth, the soft *bokashi* shading around her eyes and the realism of her right hand create the illusion of solid forms. The woman has a specific personality. The checked pattern on her kimono follows the folds of her arms in a more realistic way than in the past.

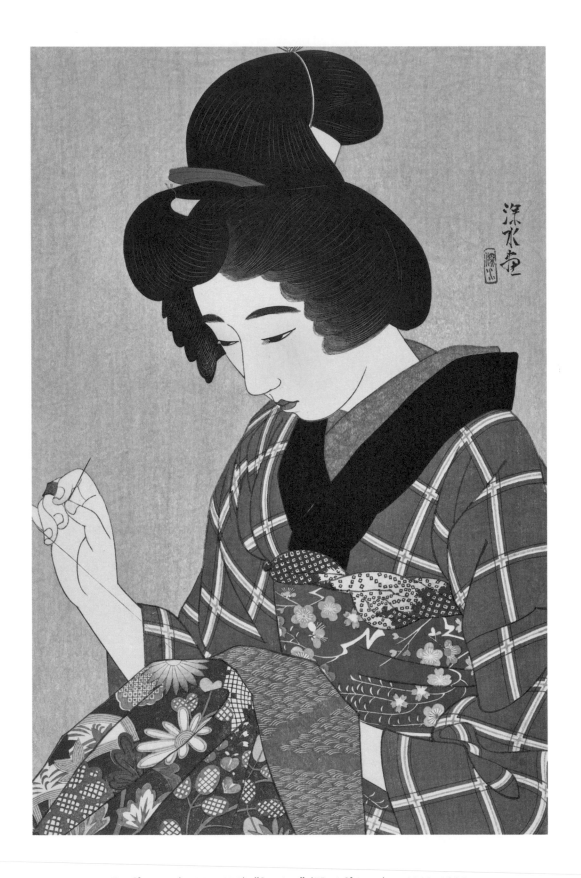

Ito Shinsui (1898–1972), "Sewing" (*Hari Shigoto*), *c.* 1912–1925

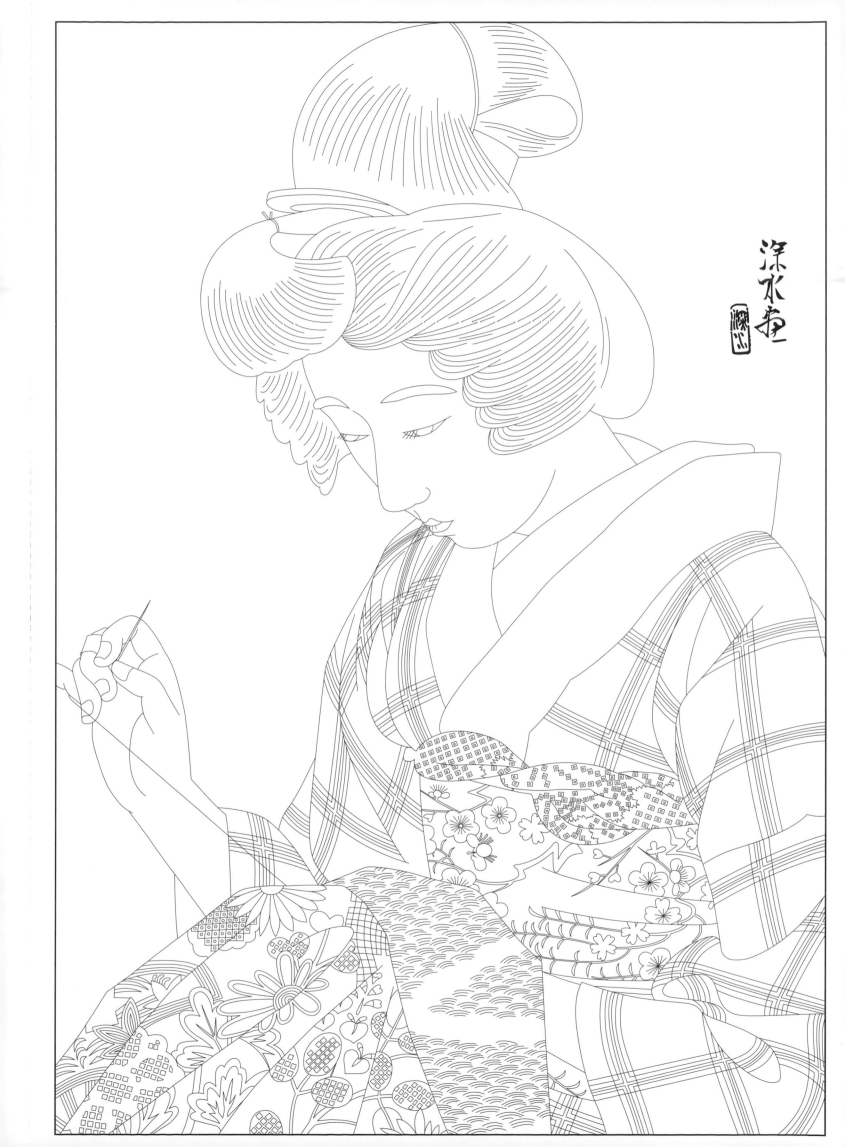

Ito Shinsui (1898–1972), "Sewing" (*Hari Shigoto*), *c.* 1912–1925

Kobayakawa Kiyoshi

(1899–1948)

"Pedicure" (*Tsume*), no. 3 in the series "Modern Fashionable Styles"
(*Kindai jisei sho*), also known as "Styles of Contemporary Make-up," 1930

Kobayakawa Kiyoshi is best known for designing woodblock prints of modern Japanese women. He was a contemporary of Ito Shinsui (see pp. 77 and 89). Although he exhibited *nihonga* (Japanese-style painting) in the 1920s and 1930s, he began to develop an interest in *ukiyo-e* and in 1930–1931 designed and self-published a series of six *bijin* prints in the *shin hanga* ("new print") style of realism—(1) Tipsy (*Horo yoi*), (2) Powdering the Face (*Kesho*), (3) Pedicure (*Tsume*), (4) Expression of Eyes (*Hitomi*), (5) Black Hair (*Kurokami*) and (6) Lipstick (*Kuchibeni*). All but the first one depict Japanese women engaged in personal feminine tasks, though in renditions not common among Japanese print artists prior to the 1930s. For example, "Black Hair" shows a kneeling nude with a small towel draped across her lap combing her long black glossy hair. In the print shown here, "Pedicure," a young woman is clipping her toenails. Her body is placed in a natural position for the task at hand and her facial expression indicates she is intent on the job. The drawing of her hands and foot is exceptional. A cloth on the floor catches the clippings. It is a relatively simple but masterful print.

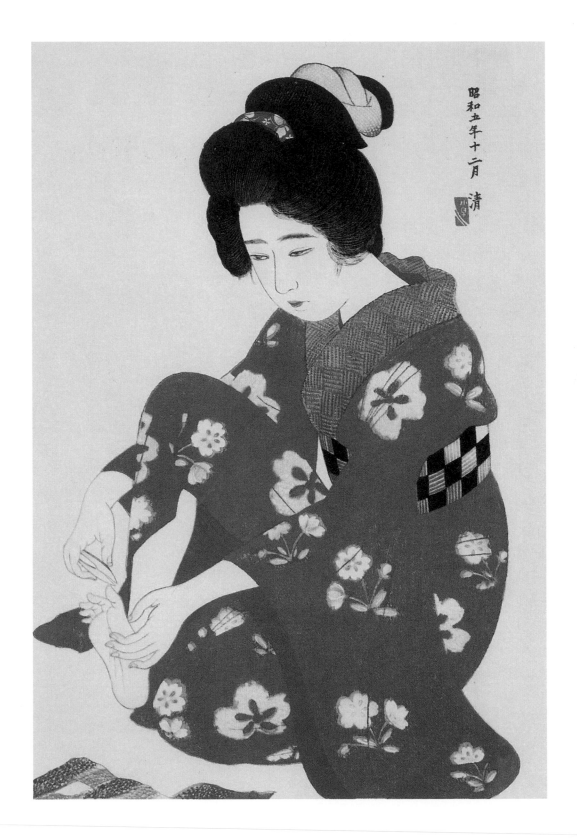

Kobayakawa Kiyoshi (1899–1948), "Pedicure" (*Tsume*), no. 3 in the series
"Modern Fashionable Styles" (*Kindai jisei sho*), a.k.a. "Styles of Contemporary Make-up," 1930

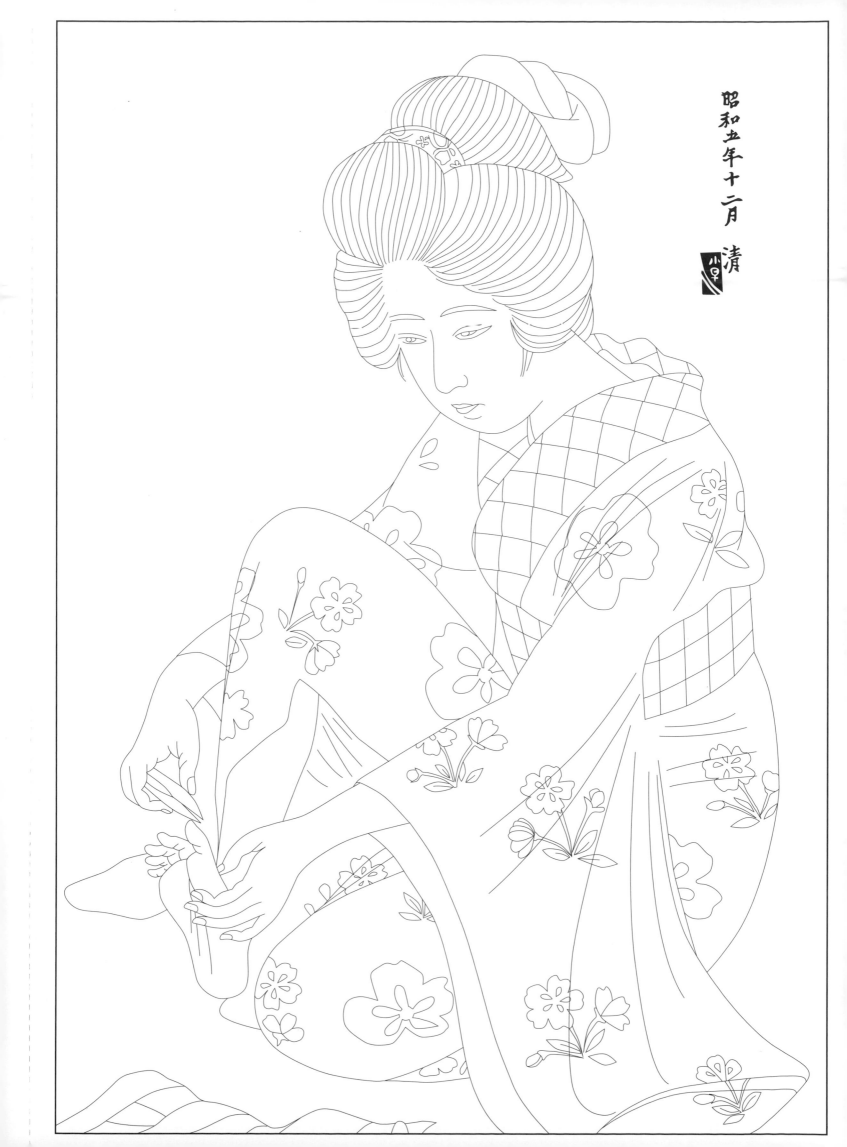

Kobayakawa Kiyoshi (1899–1948), "Pedicure" (*Tsume*), no. 3 in the series
"Modern Fashionable Styles" (*Kindai jisei sho*), a.k.a. "Styles of Contemporary Make-up," 1930

Kobayakawa Kiyoshi

(1896–1948)

"Tipsy" (*Horo yoi*), no. 1 in the series "Modern Fashionable Styles"
(*Kindai jisei sho*), also known as "Styles of Contemporary Make-up," 1930

In the early twentieth century, young Japanese women were encouraged to aspire to an idealized image of femininity epitomized by the good wife and the wise mother. As more and more young women came to be educated in a new school system, some began to question the traditional role of women. They became more aware of the value of self-achievement and individualism. Modern girls (*moga*) started to appear in public—on the streets and in cafés. "Tipsy", no. 1 in Kobayakawa Kiyoshi's series "Modern Fashionable Styles" (see also p. 81), is remarkable for its candid portrayal of a modern girl. Unsurprisingly, the print was considered quite risqué when it was first published. It depicts a Japanese woman dressed in the latest contemporary Western fashion, a sleeveless, low-cut shift as opposed to an enveloping kimono. She wears a necklace, ring and watch, has bobbed hair and heavy make-up and is drinking a cocktail and smoking a cigarette. Her flirtatious, bleary-eyed gaze and her lightly flushed cheeks indicate that she is intoxicated. She very clearly epitomizes the modern woman who resists and questions the role of the good wife and the wise mother.

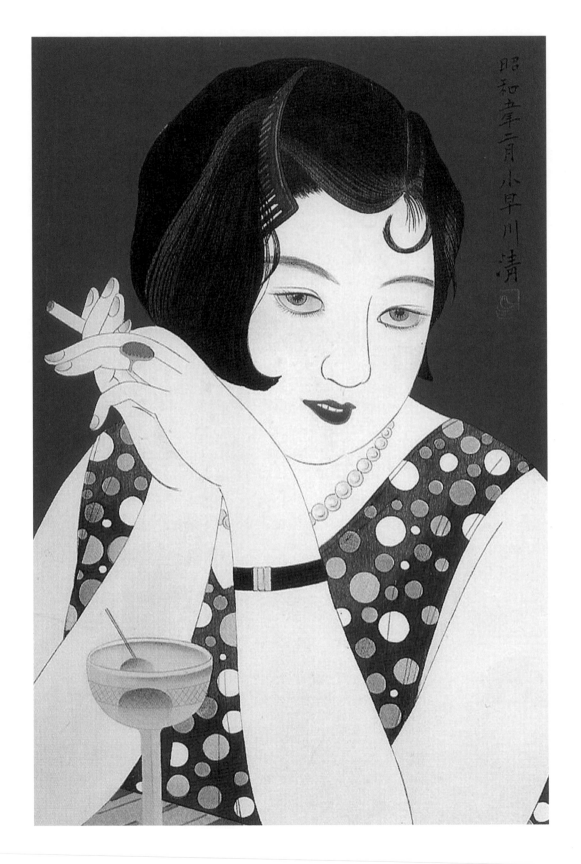

Kobayakawa Kiyoshi (1899–1948), "Tipsy" (*Horo yoi*), no. 1 in the series
"Modern Fashionable Styles" (*Kindai jisei sho*), a.k.a. "Styles of Contemporary Make-up," 1930

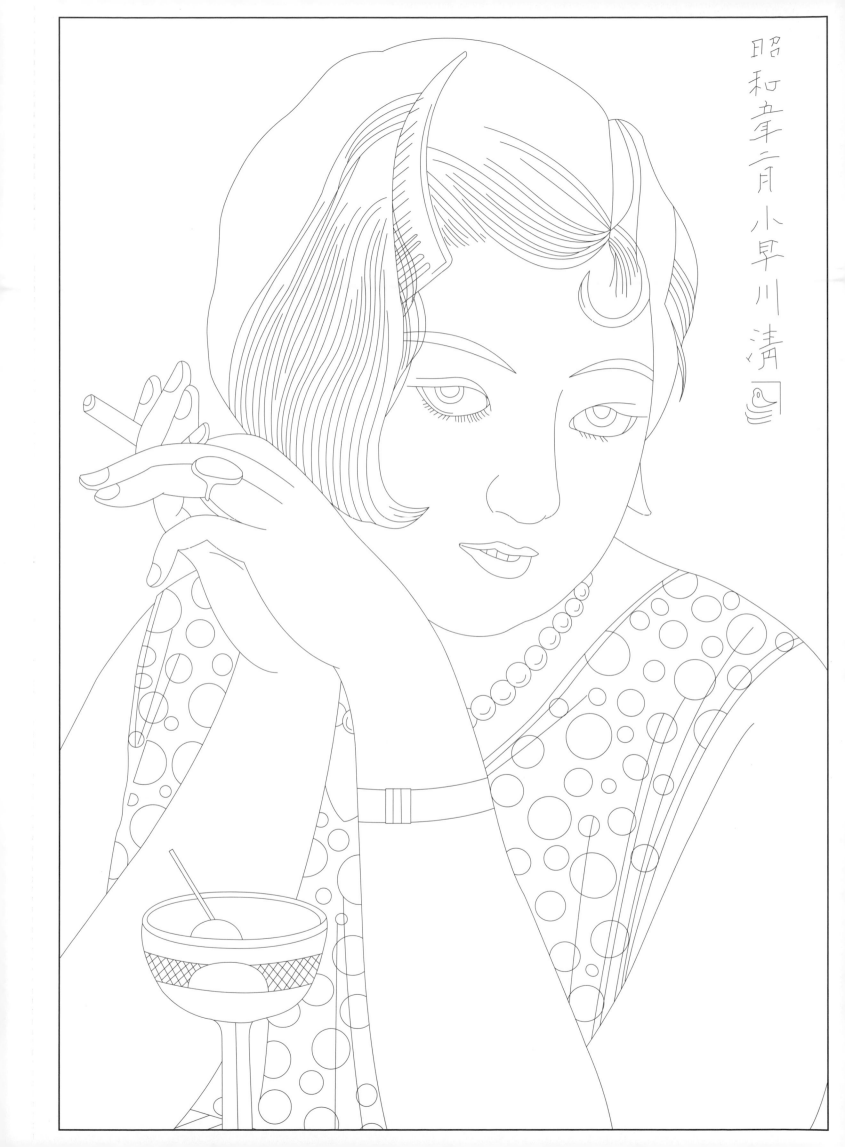

Kobayakawa Kiyoshi (1899–1948), "Tipsy" (*Horo yoi*), no. 1 in the series
"Modern Fashionable Styles" (*Kindai jisei sho*), a.k.a. "Styles of Contemporary Make-up," 1930

Ito Shinsui

(1898–1972)

"Snowstorm" (*Fubuki*), from the second series of "Modern Beauties"
(*Gendai bijin shu dai-nishu*), 1932

Ito Shinsui was highly regarded as a *shin hanga* woodblock print artist (see also p. 77) and was an important member of Watanabe Shozaburo's team making designs that appealed to Western audiences. He developed a technique, which was considered revolutionary at the time, of creating a "master painting" in watercolors from which the craftsmen employed by Watanabe could make the actual prints. His execution of the young girl's face in this print is as good as any to be seen in printmaking. The shape of the girl's eyes as she looks downwards make her appear oblivious to the snowstorm raging around her. Drawing umbrellas (*bangasa*), especially half-opened ones, was always a challenge to the print artist but here it appears completely realistic. The checked pattern on the woman's coat also follows the folds in a highly realistic way compared with the way fabric patterns ran across figures in earlier *ukiyo-e* without any concern for the folds in the fabric, including the sleeves.

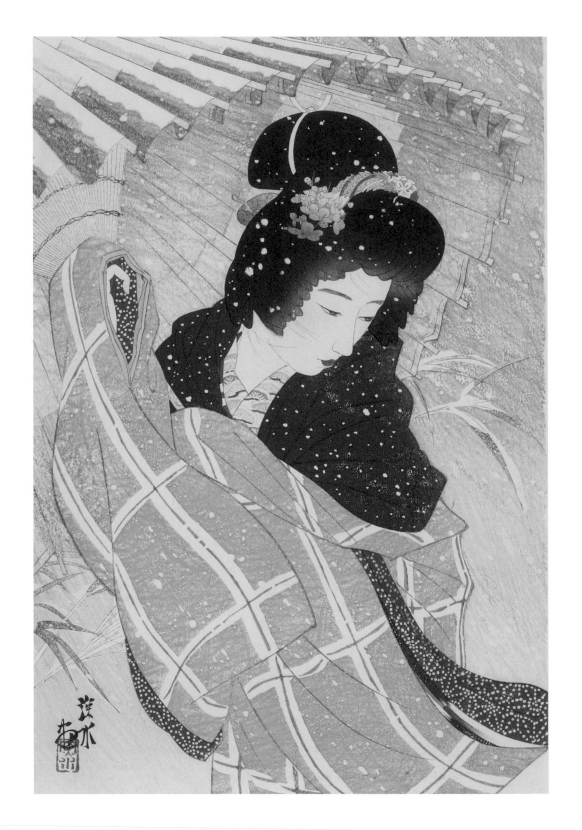

Ito Shinsui (1898–1972), "Snowstorm" (*Fubuki*),
from the second series of "Modern Beauties" (*Gendai bijin shu dai-nishu*), 1932

Ito Shinsui (1898–1972), "Snowstorm" (*Fubuki*),
from the second series of "Modern Beauties" (*Gendai bijin shu dai-nishu*), 1932

Uemura Shoen

(1875–1949)
"Composition of a Poem," 1942

The last phase of Uemura Shoen's life (see also p. 73) was also her most fertile, noteworthy for large works painted on silk with mineral pigments (*iwaenogu*). Her masterpieces of this period portray ordinary, dignified women—not the courtesans of *bijin-ga* woodblock prints—engaged in private, domestic activities, such as sewing, or dressed to go out in all their finery. Her plain, uncluttered backgrounds allowed her subjects to stand out. She used soft, neat lines and light, calm colors. Above all, she paid great attention to the details of a woman's costume—the color coordination of kimono and *obi* and the design and texture of different fabrics—as well as the choice of their hair combs and ornaments. The subtle coloring of her women's faces has led to criticism that she created "porcelain dolls" rather than women of flesh and blood. Nonetheless, as this print shows of an elegant woman composing a poem, she was a highly gifted artist of a distinct style of *bijin-ga*.

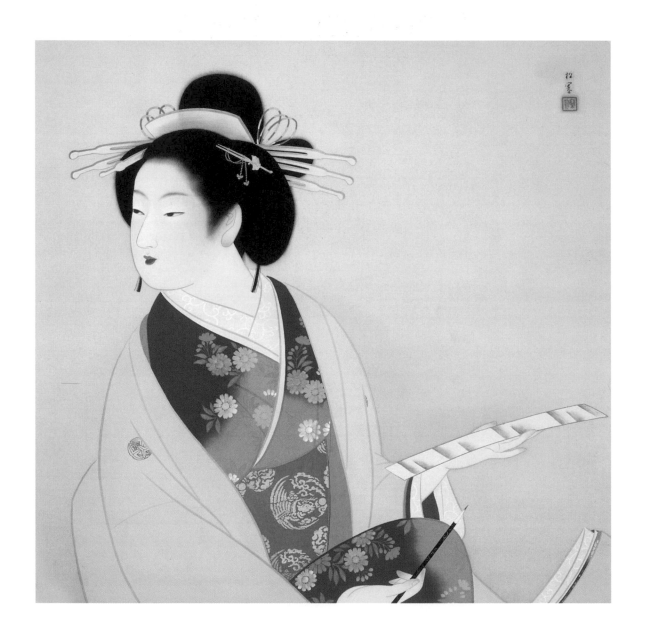

Uemura Shoen (1875–1949), "Composition of a Poem," 1942